CONTENTS

FOREWORD
6

INTRODUCTION
9

ILLUSTRATIONS
17

ARTISTS' STATEMENTS
73

THE PINHOLE AND
THE ARTIST

NURTURED by the political and social countercultures that were flourishing then, the art of photography saw a renaissance of interest in alternative photographic processes beginning in the late 1960s. In part, the revival of such processes was intended to liberate photography from many of the aesthetic and technical conventions that had held sway for two generations. The principal target under attack was the black and white gelatin silver print which had dominated art photography since the 1920s and which was viewed by many as being symbolically—if not directly—the product of a decaying and dehumanizing machine culture. In addition to being perceived as a technically and aesthetically limiting process, traditional black and white photography also seemed to be increasingly isolated from the extraordinary energy being generated in the other arts, an energy that was partly due to the shedding of the rigid demarcations between media.

Most of the alternative processes that were revived and popularized during this time were printing processes that had been abandoned or widely ignored for decades and which provided the artist with ways of making photographic prints other than the standard black and white print. Processes such as gum printing, platinum and palladium printing, hand-pulled photogravure, cyanotype, and Van Dyke offered the photographer more freedom with color, image content, print surface, and so on. Furthermore, each of these processes involved handwork to a greater or lesser extent—typically the hand-coating of homebrewed emulsions on handmade printing papers—and many of them circumvented the traditional darkroom entirely, relying upon contact printing in the sunlight rather than the use of an enlarger.

The infusion of all these craft-based processes breathed new life into photography by greatly expanding the range of objects that are considered "photographs" to include everything from photographic quilts to sculptural works to elaborately handcrafted artists' books.

Pinhole photography, unlike the alternative methods with which it is usually linked, is actually an alternative camera process rather than a printing process, and as such it poses a special problem for the photographic historian. Superficially, at least, the pinhole camera is simply another form of camera, like the 35mm or the 8 × 10-inch view camera. A negative made from a pinhole camera may be printed on any type of photographic paper surface, including traditional black and white paper. And even the fact that pinhole photography and lens-based photography are based on different optical principles does not guarantee that one can distinguish a pinhole image from a lens-made one. In spite of this, there is widespread sentiment that pinhole photography has an aesthetic all its own.

Much of the recent popularity of pinhole photography is due to a perception that the medium has become increasingly dominated by camera technology at the expense

of primary art functions, such as vision, originality, mastery of materials, and so on. The camera industry's attempt to persuade amateur photographers that a short cut to "better" pictures lies in the use of new camera technologies (whether it be complex camera "systems" with a bagful of new gadgets and whizzbangs, a fully automatic camera, or an instant print camera) has traditionally drawn a sharply negative reaction from the community of art photographers. And whenever the pendulum swings the farthest away from the twentieth century infatuation with cameras, pinhole photography has been one of the main alternatives. To make and use a pinhole camera requires no gadgets, only some basic scientific knowledge and some persistence, a great deal of user inventiveness, an acceptable level of chance, and a certain amount—often creative—of user error.

The literature on the aesthetics and appreciation of pinhole photography is replete with words like "honest," "direct," and "real." Schoolchildren and beginning photographers make pinhole cameras out of oatmeal boxes and coffee cans, in part because it's a simple way to learn the fundamental elements of photography and photographic optics without having to deal with the technical aspects of more complex cameras. The pinhole camera is also used as an *artistic* learning tool for much the same reason. It allows photographers—beginning or advanced—to circumvent many of the stumbling blocks that can distract them from coming to terms with their vision and subjects. There is a widespread conviction that a negative produced from a simple, homemade camera seems to be more completely the result of the photographer's own labor and knowledge than does one made from a 35mm camera. It's like the difference between lovingly growing one's vegetables in a backyard garden and buying them at the supermarket.

Broadly speaking, pinhole photography has attracted photographers for two basic reasons: for the unique brand of optics that only the pinhole camera can provide, and for the promise of a back-to-basics ambience and a holistic approach to the medium. Insofar as pinhole optics noticeably affect the appearance of some images, I think we could correctly speak of a "pinhole aesthetic."

Because of the peculiar optics of using a lensless aperture as a means of admitting light to the light-sensitive material inside the camera, pinhole images are free of the various distortions caused by lenses and benefit from a universal depth of field (for all practical purposes, at least). This means that everything in the image is equally in focus (or out of focus, as the case may be), regardless of distance. It is interesting to note that, over the course of this century, pinhole photography has been used for substantially different aesthetic ends. When pinhole photography had its first, albeit modest, popularity among the pictorialist photographers during the decades just before and after World War I, the principal optical appeal was the "impressionistic" look that the pinhole camera's uniform atmospheric softness could give an image. This impressionistic look has considerably less appeal to contemporary photographers, who, when they employ a somewhat less-than-sharply-focused image, have something entirely different in mind, usually an extreme, almost cinematic subjectivity or a visual suggestion of memory.

More frequently, one sees pinhole photographers exploiting the universal depth of field in order to depict the world as an unbroken, equally focused spatial continuum. Everything from a few inches to a few hundred yards away from the lens can be made to appear equally sharp (which is something that our eyes cannot accomplish), with results that are sometimes subtle, sometimes outrageous. Photographers have long played with

the optical distortions that lenses can cause; the most well-known examples are the nude studies by André Kertesz and Bill Brandt and the Polaroid self-portraits of Lucas Samaras. But the distortions made by pinhole cameras appear to be more perplexing than lens-created distortions. Somewhat like the man who has just shaved off his moustache to the vague puzzlement of his friends who cannot figure out what has changed, pinhole optics are tantalizingly rational and familiar, yet disconcertingly counter to all of our experience.

But for a great deal of pinhole imagery, in which optical considerations play a negligible role, I think we must speak of a *tradition*—however brief it may be—of recent photographic practice that manifests itself more in subject matter and in the photographer's approach to subject matter. Many pinhole images are made "around the house," so to speak. Portraits, figure studies, still lifes, and domestic landscapes (yards, gardens, patios, etc.) are common genre for pinhole photographers. While this is partly due to the long exposure times that are required, it also is apparent that many of the photographers who choose to make these kind of pinhole images do so deliberately in order to reduce the variables they are working with to a few simple, well-known elements—perspective, the quality of light, the surface of objects, for example.

Inevitably perhaps, the renaissance in pinhole photography has led to a growing interest in the cameras themselves. The most common type of pinhole camera is made from "recycled" materials such as oatmeal boxes and coffee cans. But the serious pinhole photographer soon either wants a more permanent camera or starts testing the limits by making a variety of cameras. Increasingly, one sees pinhole cameras that are elaborately, even expensively, handcrafted objects. There are panoramic, multi-aperture cameras that allow numerous overlapping images to be made with a single exposure, and even modified cameras, which formerly had a lens but have been converted to pinhole use. It is this latter type of camera that gives us such oddities as a pinhole image on Polaroid materials.

If any philosophy is characteristic of the whole range of pinhole photography, it would be that of exploration. Pinhole photographers often seem to be the type of people who have chucked their old cameras into storage and headed off for one of the frontiers of photography. It is a frontier marked by experimentation and risk-taking, and where pure science reigns without much interference from technology. Building one's own camera out of readily available materials and poking a hole in one side for a "lens"—all of which requires a "do it yourself" attitude—seems a peculiarly American way to go about picture making. No matter how crude or fancy, cheap or expensive the construction of the camera may be, the major factors determining image quality are the precision of one's mathematics and the strength of one's personal vision, not the cost of one's equipment.

Terence Pitts, Curator
Center for Creative Photography

HISTORY OF THE VISIONARY PINHOLE

Art despises no means, however unimposing, if it can only by that way reach the coveted goal. We have heard so much of the photographic lens, and have so completely depended upon it in our picture making, that there is a pleasant fascination in the idea of making photographs without a lens.

J. B. Thompson, 1901[1]

THERE is no more tranquil nor more honest form of message making than pinhole photography. A tiny hole, placed in the side of a light-tight container, allows bundles of light rays to pass in a direct, unaltered line from an object outside the container to photographic material held within. Objects silently draw their own portraits with innumerable dots of light-reflected information. With the pinhole technique, there are no complex lenses, no clicking shutters, no whirring auto-winds. There is merely an aperture and an artist that invite the world to leave its mark in the form of mysterious imagery.

It is not because the technique is so unimposing that it has remained virtually unnoticed and unmentioned in photographic history until the present. Rather, history's lack of attention stems from the fact that a significant body of imagery deserving artistic notice has not existed until the past ten years. Until recently, all imagery made with the pinhole imitated lens-formed photographs, or was scientific or educational in aspect.

Perhaps photographers in the past did not pursue the artistic possibilities of the technique because they did not know what to call it. The current and probably the first name given the process suffers from misnomer since rarely, if ever, is the aperture actually formed with a pin. Although the term *pinhole* has been used to signify an accidental hole in a camera bellows or film emulsion, it is no accident, but rather a marvel, that through a tiny circular opening dreams and other realities can leave their enchanting design.

In 1895, F. W. Mills renamed the tiny hole *stenope* after the Greek term *stenos*, meaning narrow or confined. *Stenopaic,* however, was never so popular a name as *lensless*. And the term *rectigraphic,* used by Rev. J. B. Thompson in 1901, was probably never used by anyone but him to refer to pinhole photography. The rationale behind Thompson's new name was that lensless was too negative a term since "directness and correctness are precisely the two distinctive features of pinhole photography."[2] But, for whatever reason, *rectus*, meaning direct and right, was not the correct term for the technique and, misnomer or not, pinhole remains the name of the process to this day.

Aristotle is the first man known to have experienced the creation of images when light passes through a tiny hole and falls upon a surface in a darkened room opposite the hole. Little is known about the pinhole experiments he made during his lifetime

(384–322 B.C.) except that he experienced the phenomenon and made record of it in his natural histories, as did the Greek mathematician Euclid in the third century B.C.

Since myths have forever supplemented history with their imaginative explanations of firsts and whys, and since myths do not exist concerning the Greeks' pinhole experiments, a tenth century Arabian nomad is often referred to as having had the first experience with a pinhole vision. As story has it, the wandering shepherd awoke from his nap to see an apparition gliding across the canvas of his tent. Frightened by what he saw, the nomad sought counsel from the scholar Ibn al Haitan. Upon examination of the nomad's tent, al Haitan found a tiny hole in the wall opposite the apparition. The wise al Haitan consoled the nomad by explaining how an eclipse, occurring at the same time, had been translated into the alarming vision by rays of light passing through the hole.

The myth entertainingly fills in where historic records fail, and it does not seem to matter how al Haitan discovered the photographic principle. Of significance is the scholar's associating pinhole imagery with a solar eclipse—with an event that punishes if experienced directly and that is steeped in superstition. Al Haitan's 1038 dissertation, "On the Form of the Eclipse," made fast the marriage between the pinhole and the mystery of natural phenomenon. The essay was introduced with the words:

> **The image of the sun at the time of the eclipse, unless it is total, demonstrates that when its light passes through a narrow, round hole and is cast on a plane opposite to the hole it takes on the form of a moonsickle.[3]**

Whether al Haitan knew about the discoveries made by the Greeks almost a thousand years before his own is a matter for conjecture. Actually, al Haitan might well have arrived at his conclusions solely from personal observation, for the separation of time and distance cleverly encapsulates singular experience, allowing many the delight of original discovery. And so, history reports that in the late 1400s Leonardo da Vinci was making his own unique observations in a dark room:

> **The experience which demonstrates how objects send their reflex images into the eye and into its lucid moisture is exhibited when the images of illuminated objects enter through a small round opening into a very dark room. You will then catch these pictures on a piece of white paper, which is placed vertically in the room not far from that opening, and you will see objects on this paper in their natural shapes or colors, but they will appear smaller and upside down, on account of crossing of the rays at the aperture.[4]**

Da Vinci's account in "Codex Atlanticus" is today's most popularly known factual description of early pinhole experience, but during his own lifetime the account lay hidden in cipher. The Renaissance scientist was ambidextrous and wrote his journals backward with his left hand. It was not until long after his death that da Vinci's experiments were decoded and read.

Once his words were untangled, it became apparent that the artist considered the eye the perfect instrument for gaining knowledge. For da Vinci, sight was insight, and

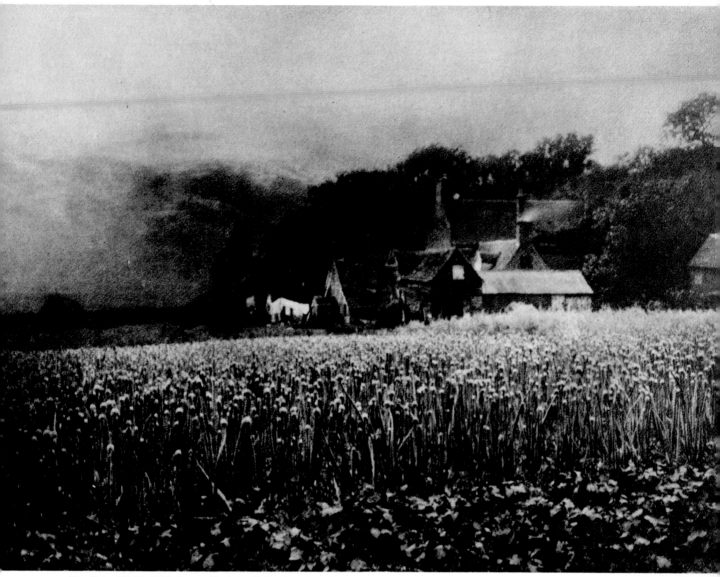

The Onion Field—1890. George Davison. Collection of the Fergus-Jean Gallery, Harbor Springs, Michigan.

his comparison of the pinhole vision and the eye bestowed upon these photographic images an aura of divine inspiration. The fact that the Italian locked his observations within his personal system of writing only adds to the element of drama that pervades the pinhole technique and its history.

A century and a half after da Vinci logged his discoveries, the Italian mathematician, physicist, and litterateur, Giovanni Baptista della Porta, made the first published mention of the *camera obscura*. His 1553 report in *Natural Magic* won him title as inventor of the image-producing device. The article was reprinted several times during della Porta's lifetime and reported publicly that artists were using camera obscuras fitted with reflecting mirrors to trace visions of the figure, the portrait, and the landscape.

11

Literally translated, the *darkened chamber* was room size when da Vinci discussed it in the fifteenth century, and it remained so until the seventeenth century. In the 1620s movable versions of the camera obscura took shape as tents. Soon after, small, portable, often collapsible, cameras were invented.

Some historians claim that della Porta fitted his camera obscura with a simple converging lens of crown glass and a diaphragm of f/30. It is universally accepted, however, that in 1568 the Venetian Daniel Barbaro described the first camera obscura fitted with a biconvex lens. Although this lens intensified the light entering the image-making device, and therefore the visibility of the picture, it did not entirely eliminate the desirability of the pinhole.

With the introduction of the lens, argument began over the accuracy of photographic seeing and over the desirability of lens versus pinhole. Experiments continued with both as they were combined with reversing mirrors, simple and complicated viewing systems, and varying focal lengths and camera sizes. As the cameras varied, so did the images they cast. Camera-traced pictures did not become standardized, therefore, but remained unique visions.

Nearly three hundred years passed between the 1553 della Porta account of an image-creating device and the 1839 announcement that, at last, light messages had been permanently captured in silver. Within the intervening years, the pinhole principle was used to observe sunspots and eclipses. It was used, as was the lensed camera obscura, by artists attempting to capture the essence of the landscape in precisely rendered perspective.

And, during the eighteenth century, the precursor of our present day travel snapshot was born as travelers making grand excursions traced visual memories on the viewing screens of their portable camera obscuras. Sketched travel scenes were tucked into journals and were taken home to become memory and evidence for the vacationer. When personal camera obscuras were not available, the traveler often paid for the novel experience of entering a permanent "camera" room where he could sit quietly and view the resort and its inhabitants outside by rotating a reflecting mirror and watching the moving images as formed upon a white table.

The acceptance and use of the camera obscura could have been predicted when Leonardo da Vinci compared eyesight and pinhole vision. What man sees, he believes, and what he believes in, he wants to possess. Photography, with its true-to-life visions of the world, satisfied man's desire to possess what he could not, in fact, obtain. As man began to accept light imagery as evidence, as concrete truth, the world and knowledge were his in the form of camera copy.

But, man wanted to control more than the here and now. He wanted to see into the future, to control his destiny. And so, while draftsmen and artists traced the camera's version of natural order, men of magic used their own interpretation of the darkened room to conjure up man's disordered future. As artists traveled into the countryside with collapsible viewing machines, fortune tellers moved from town to town, earning their way by presenting visions from beyond. The antics of hired actors dancing outside a tent or trailer-sized camera obscura became apparitions of approaching delight or doom for the naive customer within.

12

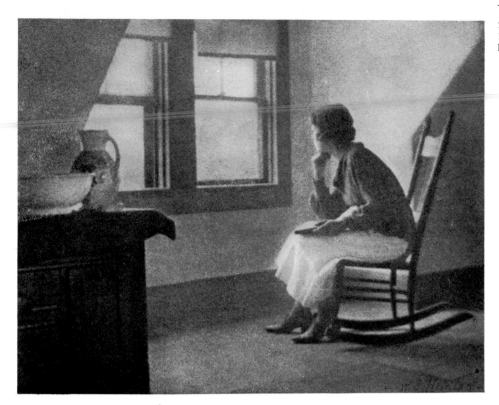

The Girl in the Attic,
1925. Raymond E.
Hanson.

These earliest photographic messages were not permanent. They were shadows that were turned into the tracing of artists or the trick of charlatans. From the very beginning, photographic imagery lingered precariously between fact and fiction, between what is and what might be. From the very beginning, whether lensed or pinhole, photography both fascinated and frightened man as he wandered in search of his rightful place in the universe.

In 1839, camera obscuras were made obsolete with the announcement of permanent photographic processes. Now man did not have to trace his imagery; now he could allow the light sensitive materials to capture the world's every detail with magic accuracy. For a while, the pinhole vision was forgotten with man's frenzy to photograph and to be photographed. The camera offered every person a new form of immortality through portraiture. It brought home the pyramids of Egypt and the White House Ruins of Arizona. It took everyone to the battlefields of the Mexican, Crimean, and Civil wars. And, by 1895, men were once again ready for the pure pinhole.

In 1895, just three years before Kodak offered its do-everything-but-snap camera, Frederick William Mills, of London, introduced his article "Stenopaic or Pinhole Photography" by citing lectures, research results, and essays concerning pinhole photography coming to his attention from as far away as Japan. His comments, including the mention that pinholes produced by Mr. Cox of Dorset were of fine quality, suggested a renewed interest in basic photographic principles.

An earlier article, written in 1856 by Sir David Brewster, hinted that someone somewhere might always have been creating pinhole imagery:

The Rev. Mr. Egerton and I have obtained photos of a bust, in the course of 10 minutes, with a very faint sun, and through an aperture less than the hundreth of an inch; and I have no doubt that when chemistry has furnished us with a material more sensitive to light, a camera without a lens, and with only a pinhole, will be the favorite instrument of the photographer.[5]

Although the lensless camera never caught on as did the Brownie, by 1905 it was reported that "hardly a month passed without a magazine article or two about pinhole photography, and several worthy pinhole devices were on the market."[6]

Mill's 1895 article, with its involved formulas for determining pinhole size in relation to camera extension, with its discussion of needle sizes and angles of view, was typical of articles that appeared in photographic literature. Of greatest concern to all authors was the creation of the perfect pinhole, and each investigator met this challenge by means of his own ingenious process.

The means devised to create pinholes were as various as formulas to determine exposure. Pages and pages of literature appeared offering charts and equations. No two authors seemed to agree upon one set of criteria. Authors often remarked about the diversity of opinion and suggested that each pinholer, out of necessity, had to determine exposure for himself through experimentation.

The problem-solving nature of the pinhole process generated a host of homemade inventions. Sliding shutters for multiholed cameras, view finders, panorama holders, angle-of-view meters, were described and illustrated in photographic periodicals such as *The Photo-Miniature: A Magazine of Photographic Information.* Published in New York from 1899 until 1932, and then renamed *The New Photographic Miniature,* this publication was a vehicle for shared research, comment, and imagery. *The American Annual of Photography,* another such publication, reported that in 1925 there were fifty-six photographic magazines printed around the world, twenty-two in the English language. And pinhole photography cyclically took its place within these publications as a novelty worth considering.

Regardless of periodic enthusiasm for the medium, however, pinhole photography remained unproven, until now, as a means of artistic expression. Lectures and articles lauded the advantages of the medium, dealt with the principles and process, and sometimes even offered token imagery. But the process was, at last, always relegated to science or education. In a 1935 *The New Photographic Miniature,* author and editor Ben J. Lubschez reported in "Pinhole Photography" that lensless photographs were given honors at an exhibition without the judges guessing how they were produced. In the same publication there also appeared articles describing the pinhole's educational and scientific possibilities. Pinhole cameras have since been built by Boy Scouts and marketed by Kodak. They have explored the insides of engines and of human beings and have been used in our space program.

Even when photographers explored the pinhole, they often approached it as did noted German photographer Lotte Jacobi. At the age of eighty-nine, Jacobi reminisced from her Deering, New Hampshire, home about her childhood experience with a pinhole camera. After meeting Daguerre, the French inventor of photography's first permanent process, Jacobi's great-grandfather became a photographer. The great-grandfather's son became a photographer, and the son after him followed suit. Jacobi did not want to be a photographer, but an actress.

In 1907, however, at the age of eleven, Jacobi decided that she wanted to take pictures. She was accustomed to helping her father in the darkroom and wondered how cameras worked. "Before you do anything else, you must build your own camera," said her father. And so, Jacobi made a pinhole camera and took pictures that she would refer to, years later, as being some of her best.

Artistic expression grows out of need, and even though Jacobi fondly remembers her lensless experience, she and the world were not ready for the pinhole vision in 1905. By 1972, however, when Kenneth A. Connors began writing a series of papers that combined scientific pinhole data with creative writing, the time was right. Within the pages of *Interest,* Connors stated that "rather than being an independent isolated worker, I am part of a popular movement." [7]

The movement to which Connors referred included a conceptual pinhole event conducted by Phillips Simkin at the Philadelphia Museum of Art. In 1974 Simkin placed 12,000 pinhole cameras in the museum and invited people to participate in an "exchange of perceptions" by using the cameras to photograph a private space. The images of these spaces were then exhibited at the museum. Simkin chose the pinhole camera as his tool because it was, in his words, "the most efficient vehicle for capturing the experience, the participation, the living moment, the idea." [8]

The late seventies were ripe for Simkin's sensitivity and for the pinhole revival that was beginning to emerge. The decade had ushered in a grand skepticism about photographic seeing. The likes of Susan Sontag dissected photography, examined every part of it, until an awful tension arose between our need for and our distrust of photographic information. Cameras were becoming faster, more sophisticated, better programed, but these instruments were meanwhile being judged more as purveyors of propaganda than as providers of truth. There was desperate need for photographic release.

Respite took shape as photographers turned to primitive image making. In the early seventies, plastic lenses, pinholes, and non-silver printmaking took the place of high-speed, high-tech photography. Workshops across the country filled with those anxious to escape modern photographic trends. Jim Shull's *The Hole Thing* lead beginners through the pinhole process. Photo magazines and journals once again described the silent, slow photographic technique, but this time they began to consider the expressive nature of serious pinhole image making.

While society continued to receive photographic messages about what it should or should not want, think, purchase, and be, the pinhole artist turned his back on convention and convenience. With his own hands, the pinhole artist fashioned cameras that would allow him to employ chance, coincidence, and intuition as he explored the mysteries of life.

Sometimes the pinhole artist used such found containers as the oatmeal box for his camera. At times, he designed beautiful brass, wood, or leather cameras that became sculptural partners to the images produced with them. Sometimes the camera's appearance related in a direct manner to the photographer's statement. But, whatever the form of the camera, there always existed a preciousness about the process of camera making. Always, the artists seemed to be reaching back in time, borrowing energy and mystery from the Arabian and his apparition.

Dreamlike pinhole images began to appear, in the late seventies, in such shows as "Altered State," "Reflections of the World of Illusion and Fantasy," "Primitive Images," and "Handmade Cameras, Contemporary Images." Reviewers of pinhole exhibits across the country spoke of the work in terms of stream of consciousness, altered relationships of time and space, illusive reality, and magnetically charged zones.

With the gesture of purchase, such establishments as the Museum of Modern Art, the Center for Creative Photography, and the San Francisco Museum of Modern Art, gave their stamp of artistic approval to the pinhole vision. With Eric Renner's Pinhole Resource in San Lorenzo, New Mexico, a life-support system for the pinhole movement was established in 1984. The nonprofit research library and photographic archive was created to act as a resource center for pinhole imagery and literature.

Interest in pinhole photography may have been reborn as part of the resurgent interest in primitive image making, but its current life thrives upon the effectiveness of its unique, sustained vision. Man is ultimately a dreamer who searches for the rainbow's end, who wishes upon the evening star, and who might even call upon a wandering fortune teller. The pinhole describes man's reverie in a manner that parallels artist Barbra Esher's description of Japanese sensibility:

> **Japan is a culture of wrappers, of postcards and books, or of concealed jealousies and desires. Layer upon layer to peel through, only to get to more wrappers. As well as creating privacy, this creates a curious mystery. Nothing is spelled out; it must be discovered. There is an unseen drama in the shadows which hide as well as describe. It is important in Japanese to talk around the subject; something is lost in being direct. If the area around the subject is described and defined, then what you have left is the thing intact; not broken down, but as it actually exists—as a beautiful, perfect whole.**

The pinhole encircles experience and offers a visionary memento of that which rests, untouched, at the center. Growing out of a need for release and mystery, the pinhole is exploring the secret center of life as in no other time in history.

NOTES

1. J. B. Thompson, "Pinhole (Lensless) Photograpy," *The Photo-Miniature*, ed. John A. Tennant, *27* (June 17, 1901), p. 97.

2. Ibid., p. 99.

3. Ibn al Haitan, "On the Form of the Eclipse," *History of Photography*, ed. J. M. Eder, 8th ed. (New York: Columbia University Press, 1945), p. 36.

4. Ibid., p. 39.

5. Brewster, Sir David, "The Stereoscope: Its History," *The New Photographic Miniature*, ed. John A. Tennant, no. 208 (1935).

6. Lubschez, Ben J., "Pinhole Photography," *The New Photographic Miniature*, no. 208 (1935).

7. Leendert Drukker, "Pinholes for the People," *Popular Photography*, (June 1975), pp. 56-59.

8. Phillips Simkin, *Popular Photography* 76 (June 1975), p. 59.

OTHER REFERENCES

The American Annual of Photograpy, ed. by Percy Y. Howe (New York: Tennant and Ward, 1917, 1925).

Connors, Dr. Kenneth A., *Interest* (School of Pharmacy, 425 North Charter St., Madison, Wis., 53706, 1972-83).

Shull, Jim, *The Hole Thing* (New York: Morgan & Morgan, Inc., 1974).

Smith, Lauren, *Pinhole Vision I* and *Pinhole Vision II* (author-published, 5980 Whittingham Drive, Dublin, Ohio, 43017, 1981).

Lauren Smith

Plumber Camera, and photograph, *Under the Acid Sink,* 1984. Peggy Ann Jones.

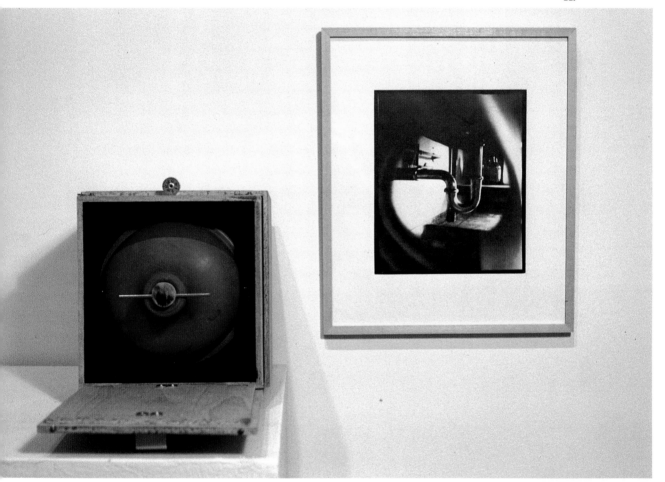

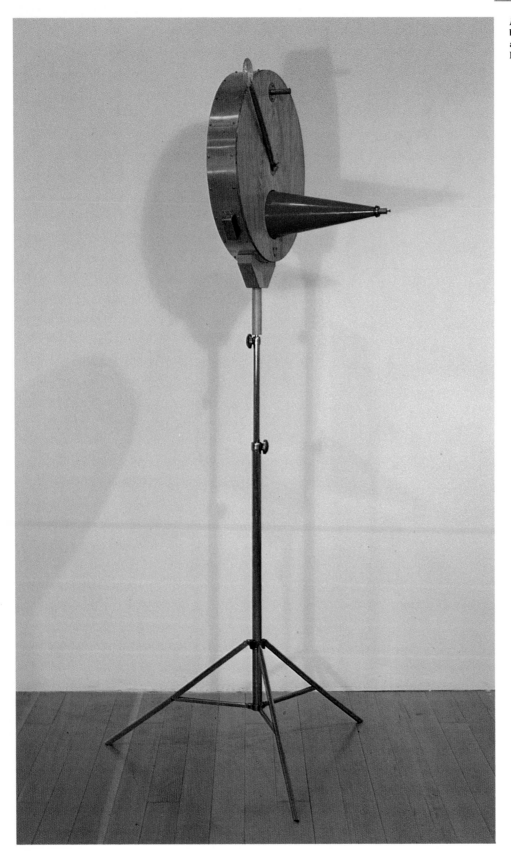

Eclipse Camera (wood, brass, plastic, aluminum), 1984. Peggy Ann Jones.

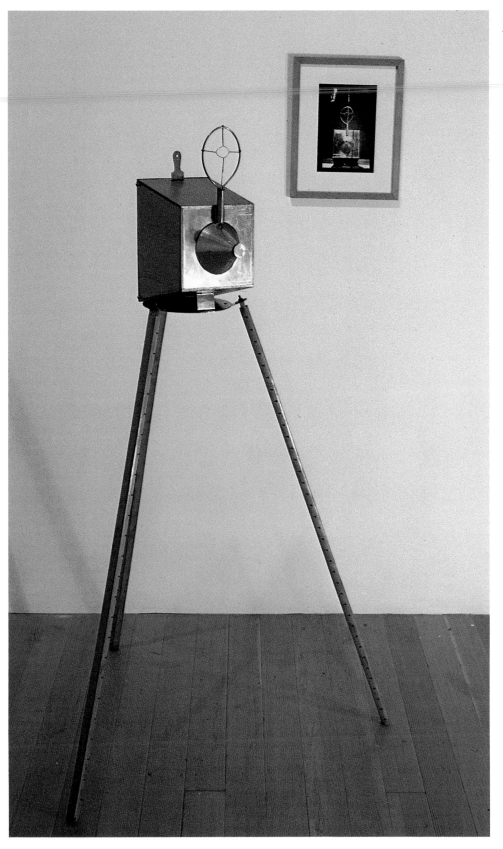

J. V. Special/Self-portrait (wood, brass), 1984. Peggy Ann Jones.

120° Pinhole Camera #1
(chipboard, paint, brass,
tape), 1983. Robert A.
Arthur.

Left to right: *4 Pinhole Camera*, 1975; *Viewfinder for 4 Pinhole Camera*, 1974; *9 Pinhole Camera No. 2*, 1970. David Lebe.

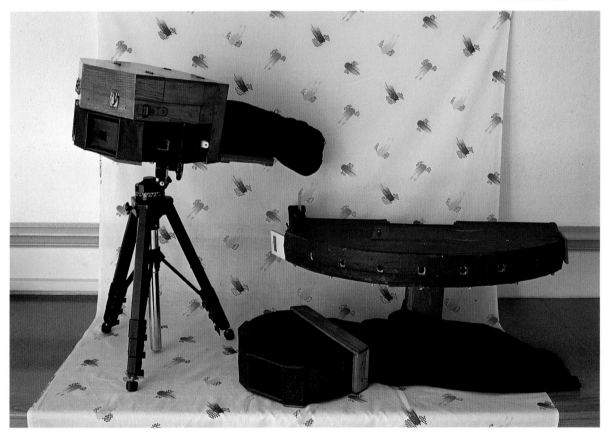

The Campbell's Soup Camera. Julie Schachter.

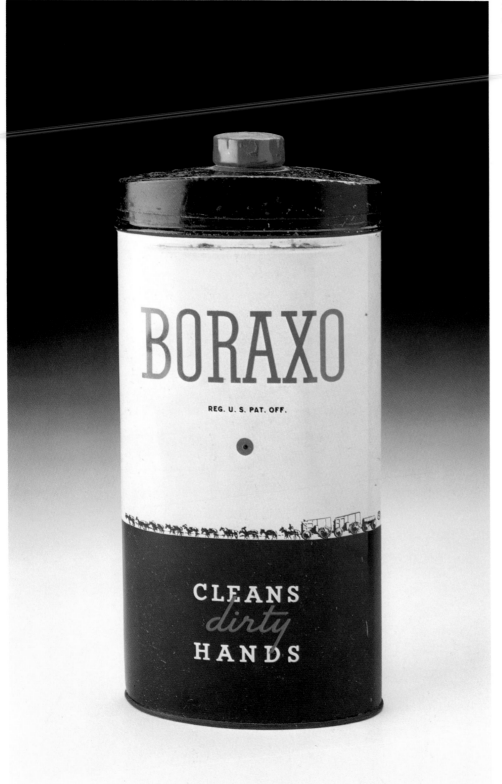

The Boraxo Camera.
Julie Schachter.

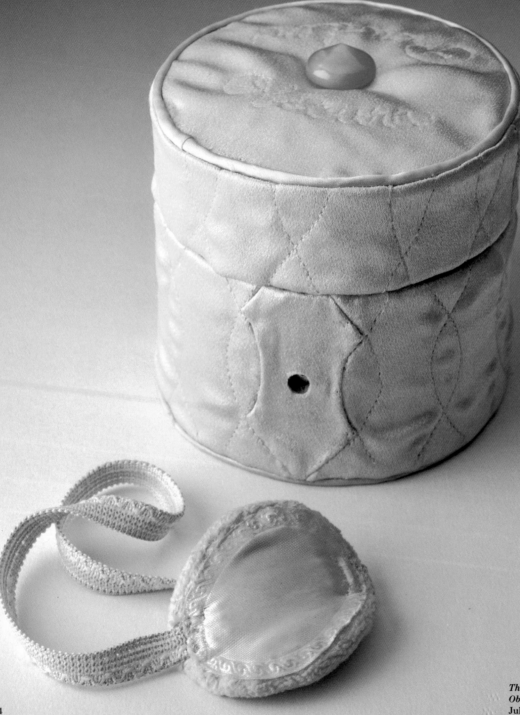

*The Powder
Obscura Camera.*
Julie Schachter.

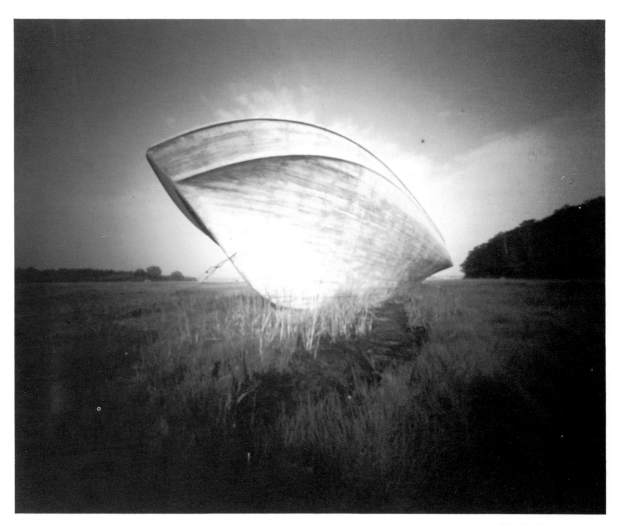

Ship Hull, Essex,
Massachusetts, 1977.
Marc Peloquin.

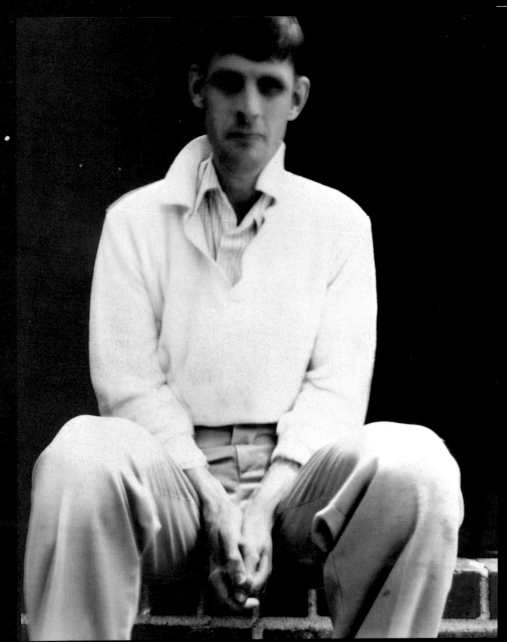

Untitled, 1983-84. Peter Reiss.

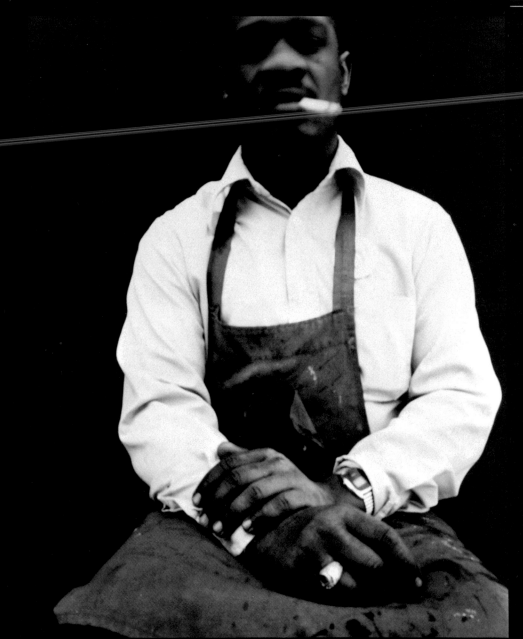

Untitled, 1983-84. Peter Reiss. 27

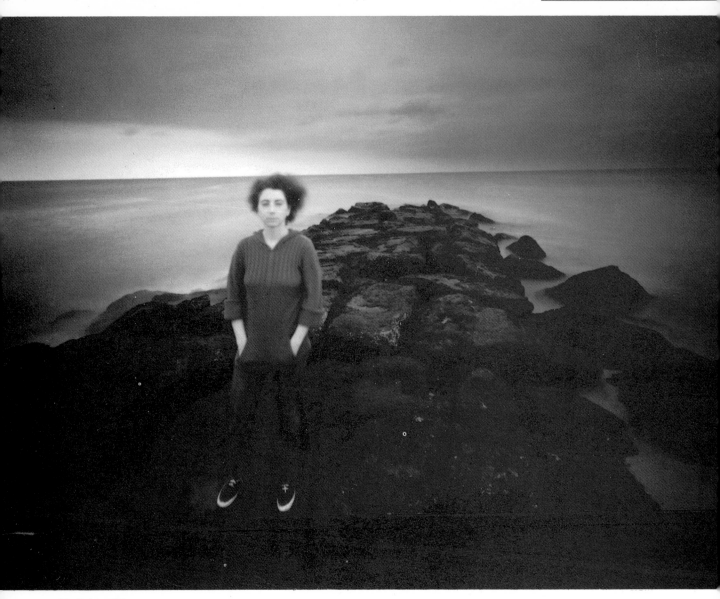

Marjorie, 1976.
Jim Haberman.

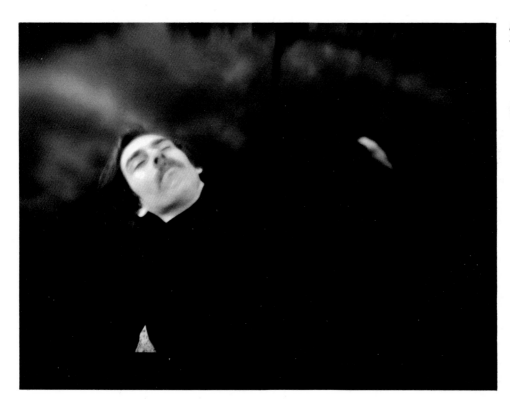

***Self-portrait*, 1977.
Jim Haberman.**

Ticul Center, Yucatan, Mexico, 1969. Eric Renner.

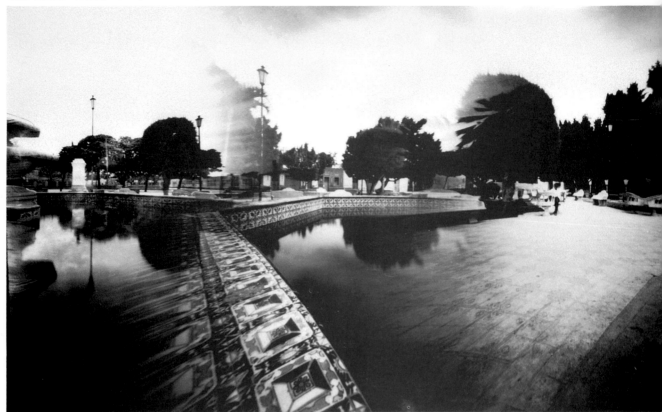

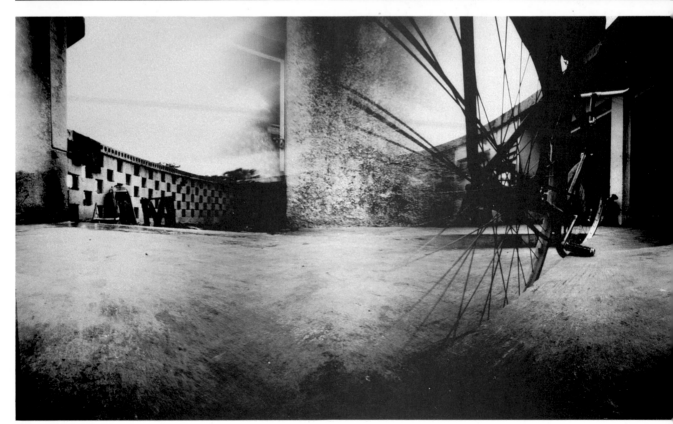

Ticul Bus Station, Yucatan, Mexico, 1969. Eric Renner.

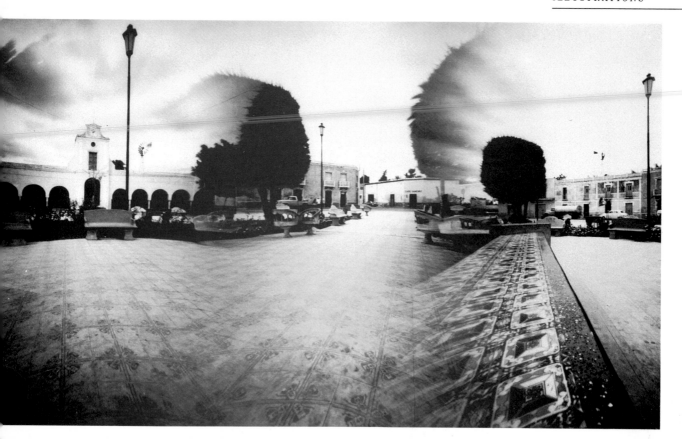

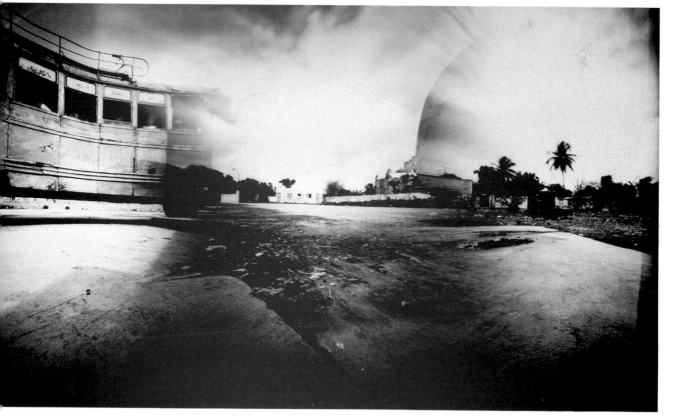

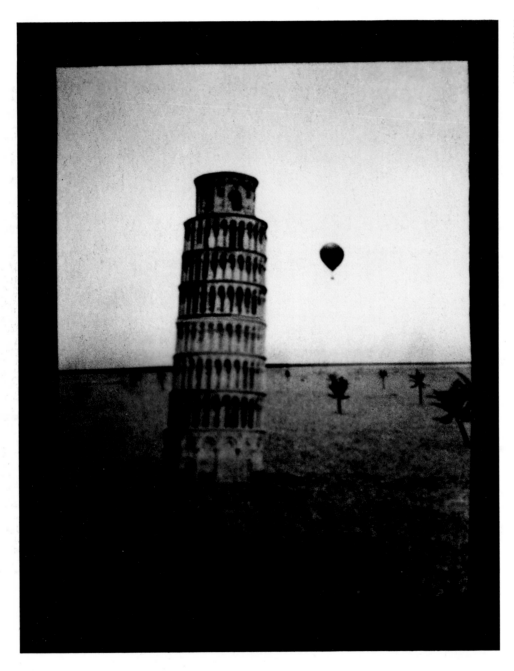

From "Expedition
Series," Chicago, 1979.
Ruth Thorne-Thomsen.
Courtesy Marcuse
Pfeifer Gallery,
New York City.

From "Expedition Series," California, 1982. Ruth Thorne-Thomsen. Courtesy Marcuse Pfeifer Gallery, New York City.

From "Expedition
Series," Yucatan,
Mexico, 1980. Ruth
Thorne-Thomsen.
Courtesy Marcuse
Pfeifer Gallery,
New York City.

From "Expedition
Series," Chicago, 1978.
Ruth Thorne-Thomsen.
Courtesy Marcuse
Pfeifer Galley,
New York City.

Maclaurin Buildings, MIT Campus, Cambridge, 1983. Robert A. Arthur.

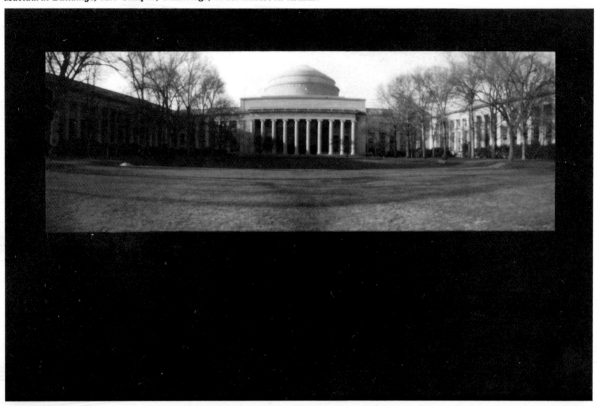

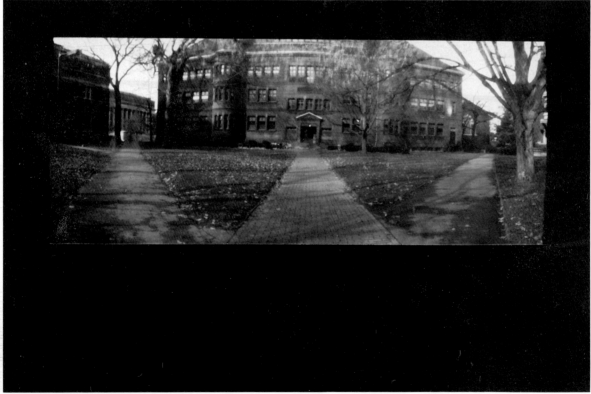

Sever Hall, Harvard University, Cambridge, 1983. Robert A. Arthur.

The New Stone Age.
Greg A. Williams.

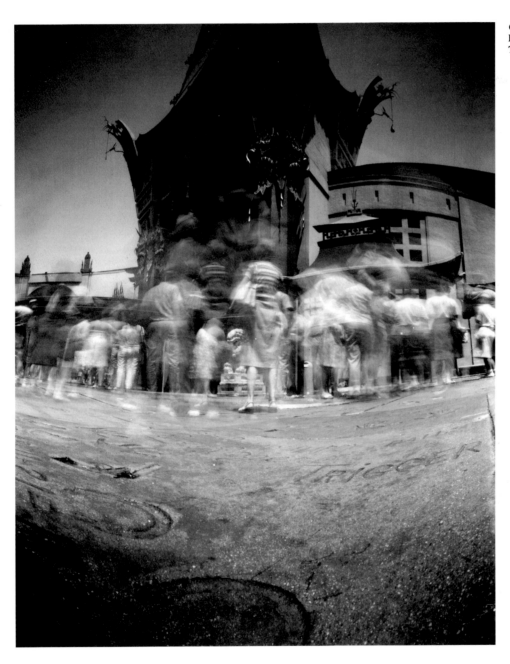

Chinese Theatre,
Hollywood, California
Tom Upton.

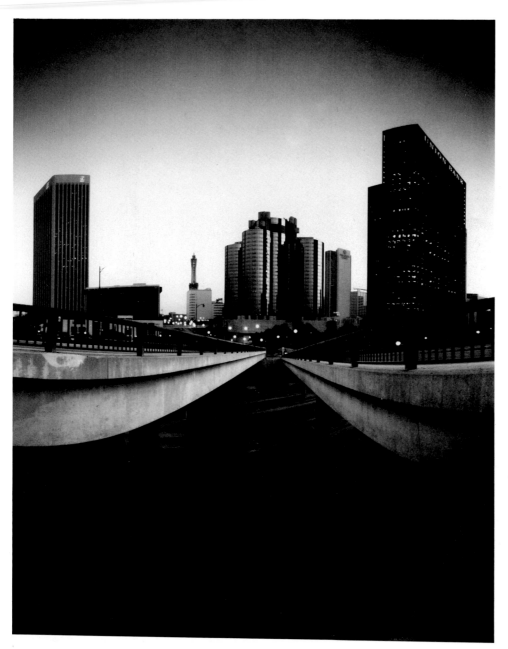

Downtown Los Angeles,
Tom Upton.

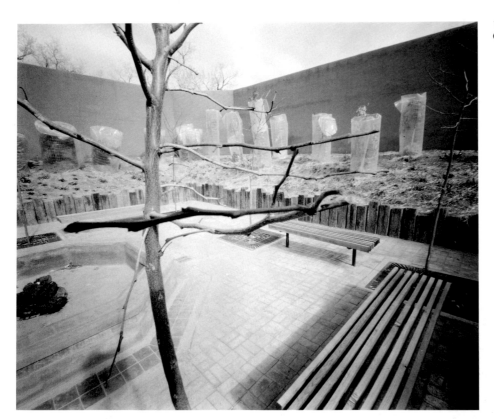

Wrapped Plants, 1980.
Clarissa Carnell.

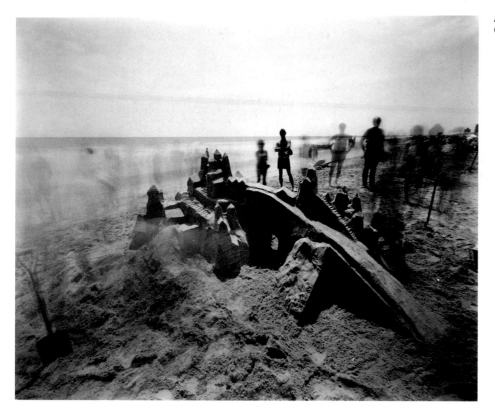

Sandcastles, 1982.
Clarissa Carnell.

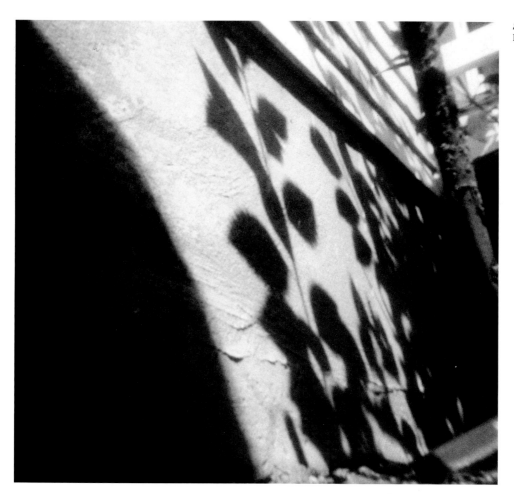

Shadows. Concetta Domenico.

Rachel and Lee, from the series "Student Portraits," 1978. Martha Madigan.

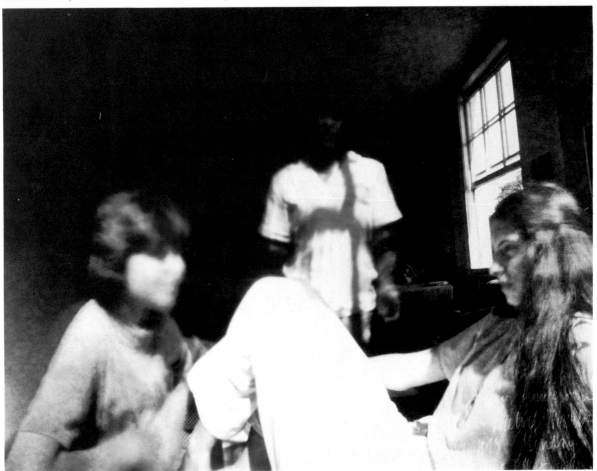

Lee: I want to talk about why it's harder for me to listen.

Rachel: I didn't even know you last year, did I?

Lee: Last year and this year are different.

Rachel: I got so busy. I didn't even know myself.

Lee: I've changed alot. Sophomore year was a great one.

Rachel: For me, too.

Lee: Sophomoric.

Rachel: There's something impersonal about sitting here with this tape recorder on.

Scott: (standing) Think I'll ruin her picture and make a big shadow.
(just walked into the picture) How long do you guys have to sit there?

Kathy and John, from the series "Student Portraits," 1978. Martha Madigan.

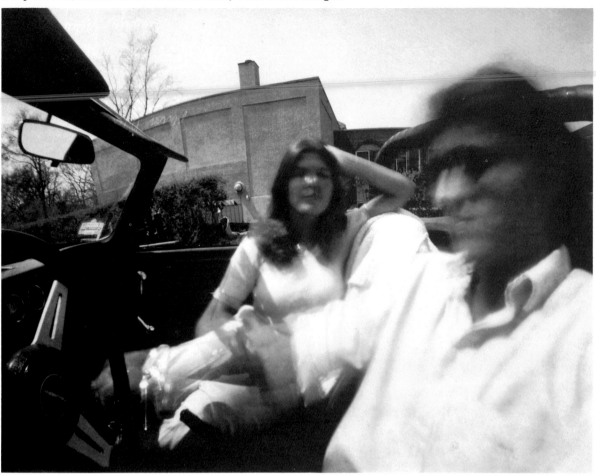

John: What do you think of having your picture taken, Kathy?

Kathy: (giggles) Oh, I don't know. I think it's nice.

John: Excellent, man. Kathy: Ready for Cypresses? (restaurant). John: Yeah. What did you....

Kathy: I just asked if I could go off campus... She said "yes," since I don't have anymore classes. Are we going to 'Godspell'? My dad told me how to get down there lastnight.

John: That's excellent. My throat's so parched. Katherine, I can't have all my senior pictures with you. Nothin' like bein' in pictures.

Kathy: I know. Did anyone else come to school today? (senior ditch day)

John: Yeah, Tower. I think I came just to be with you. I might just take one with only my car and me... You're so good. Wanna hear some music? (turns on radio) Not much to say. You're so sexy, Katherine. I can't wait to get out of here. God, it's Friday, Katherine!

Kathy: I know. We'll be together. I'm gotta get used to the way it's gonna be next year without you... when I'm a senior.

John: This is a long three minutes. Ready to go to 'Cypresses'? I'm real hungry. I'm having eggs, aren't you?

Dorothy and Kathy, from the series "Student Portraits," 1978. Martha Madigan.

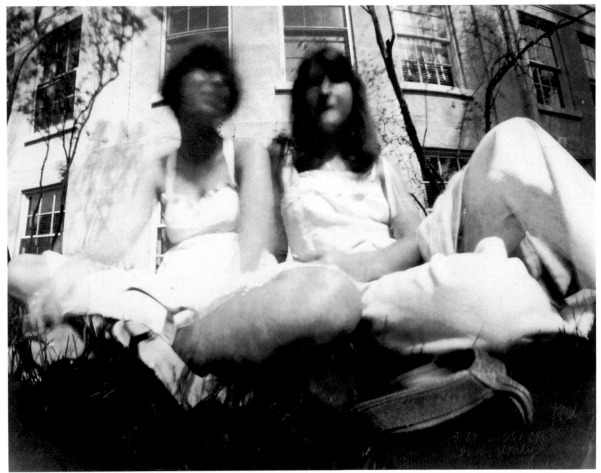

Dorothy: We tried to walk on the water in our Bible class, but we lost faith and sank.

Kathy: But that was cold. That was the problem!

Dorothy: My legs were blue for two hours. You know, alot of people think that everything's up to faith and that the stars govern you. But that's baloney, you choose everything, you know!

Kathy: You don't think anything's predestined?

Dorothy: No. I think everything's a matter of choice.

Kathy: Everything is so GREEN now that it's spring. Last year was so... different... things are so different every year.

Dorothy: I can't believe it... I don't know... not only in external things but things inside me... things change so much. Really.

Kathy: I remember your sophomore year when I was a freshman. You were just more quieter. I don't think you were as outspoken as now, which is good!

Dorothy: I wonder how long is four minutes?

Kathy: You know, once we start talking on the phone... on the phone we just keep going and you don't measure the time. But here it seems... tick...tick...tick...

Trinity Church, 1982.
Toby Lee Greenberg.

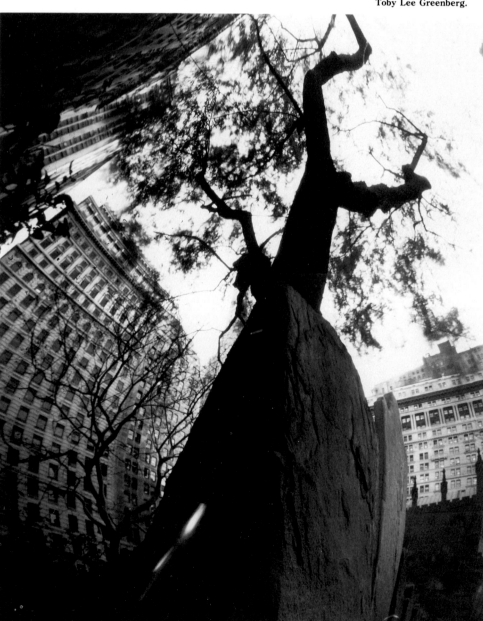

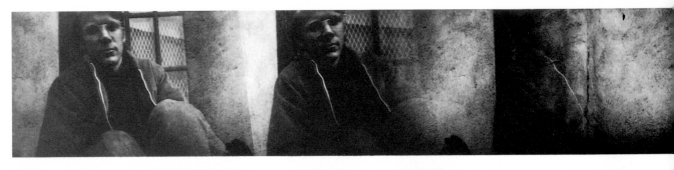

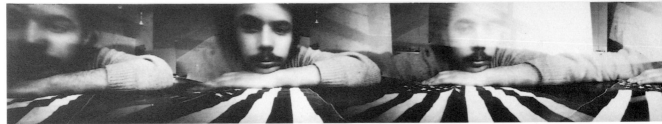

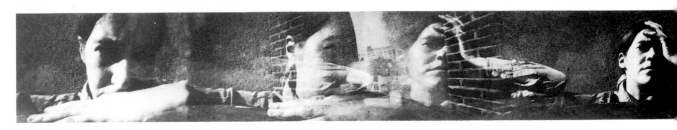

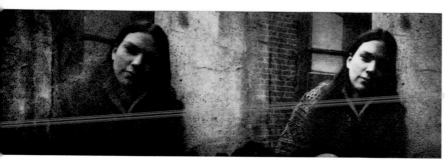

Stephen and Kathy,
1969. David Lebe.

Self-portrait, 1970.
David Lebe.

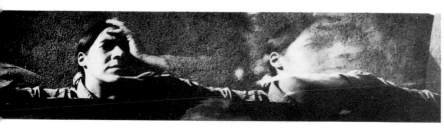

Jesse, 1970.
David Lebe.

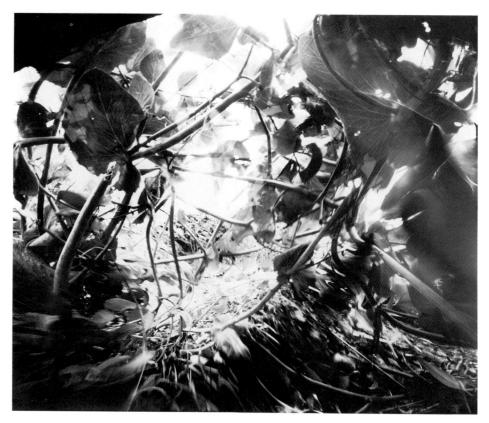

**From "Gathered Light
Series."** Patti Ambrogi.

Hilton Construction Zone. Peggy Ann Jones.

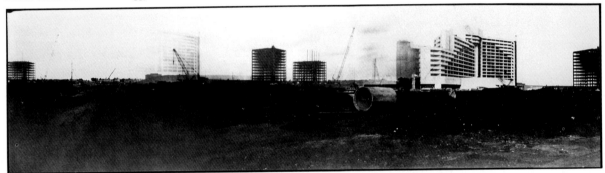

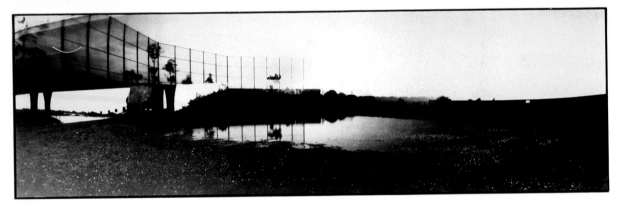

Crystal Palace. Peggy Ann Jones.

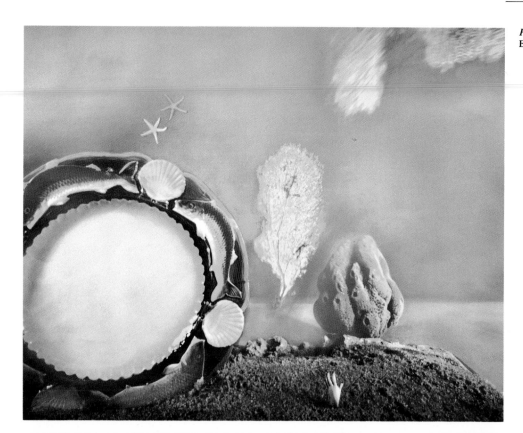

Fish Plate, 1981.
Bea Nettles.

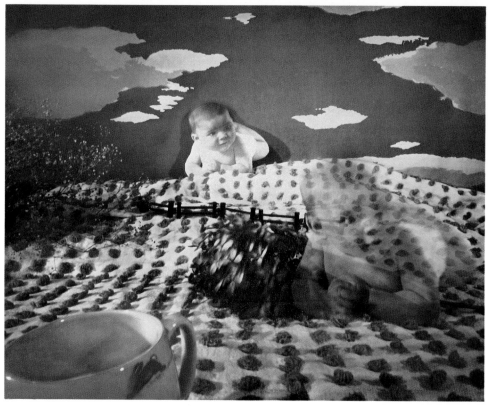

Boy and Bunny Cup,
1982. Bea Nettles.

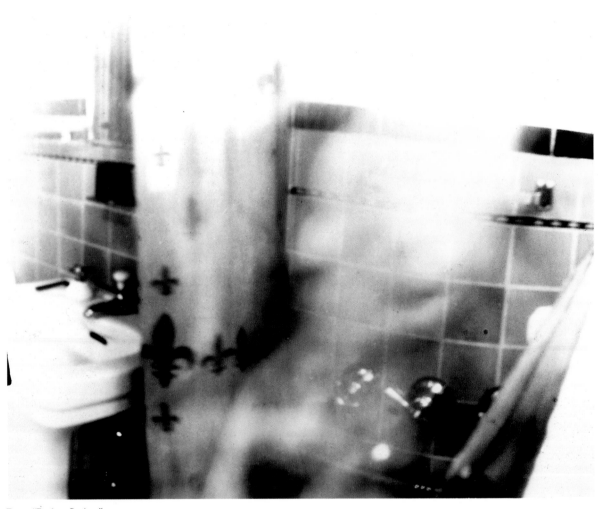

From "Bather Series."
Julie Schachter.

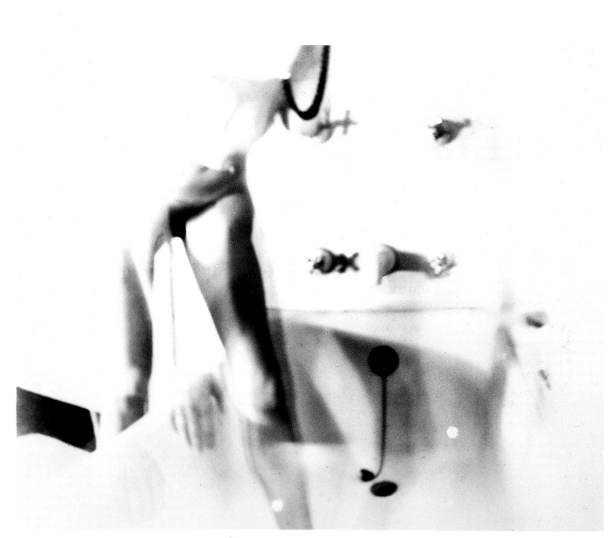

From "Bather Series."
Julie Schachter.

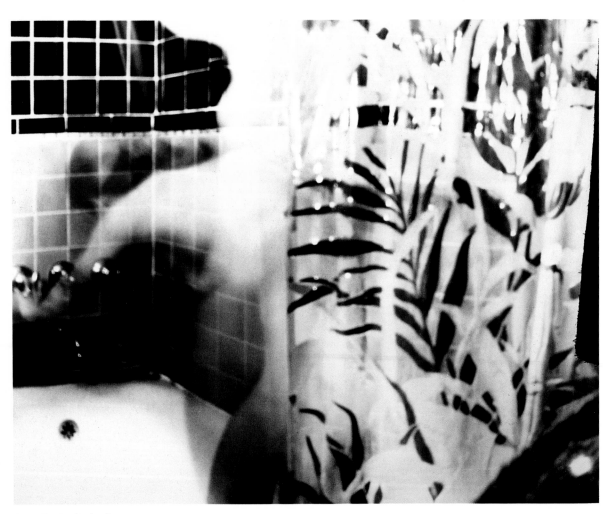

From "Bather Series."
Julie Schachter.

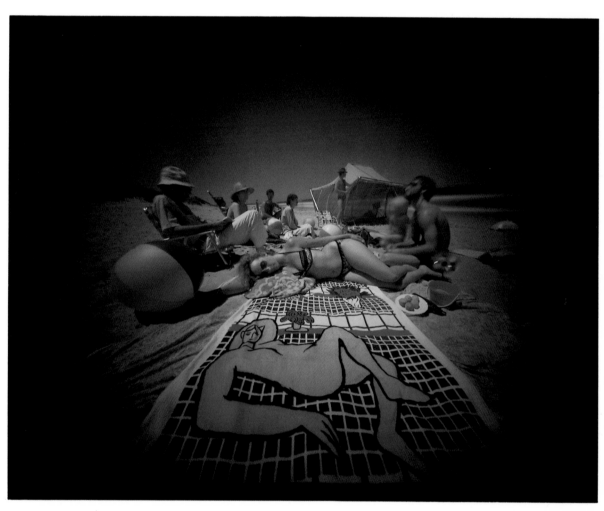

***Group at Nags Head,
N.C.,*** from "Beach
Series." Willie Anne
Wright.

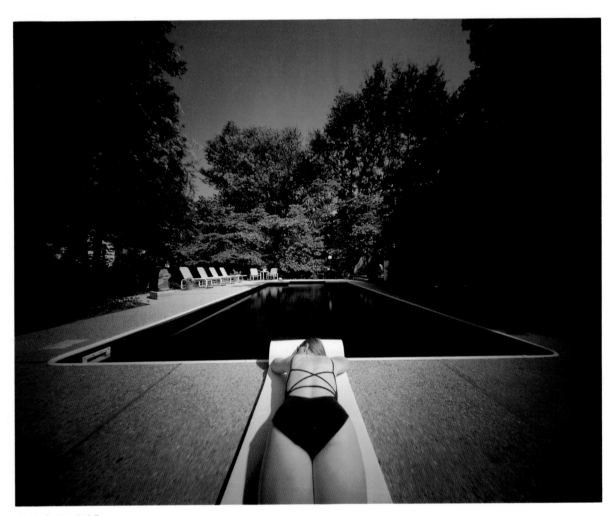

"Pools Series #10."
Willie Anne Wright.

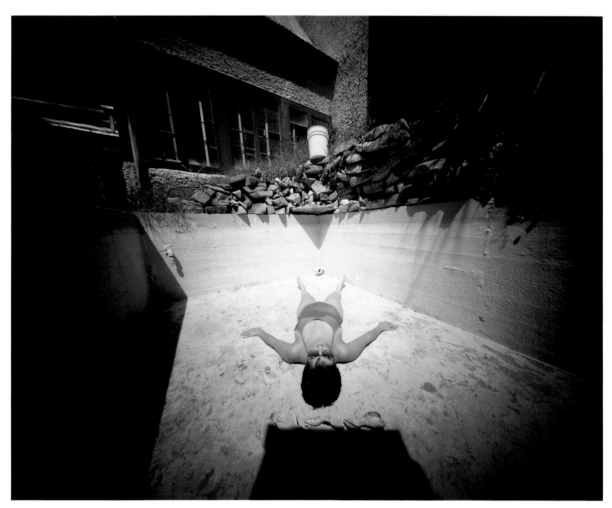

"Pools Series #21."
Willie Anne Wright.

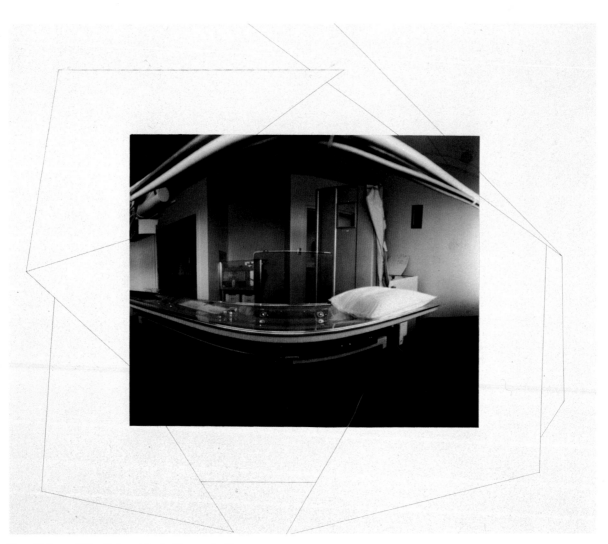

From "Primary Office Coloring Book." Lauren Smith.

From "Primary Office Coloring Book." Lauren Smith.

From "Primary Office Coloring Book." Lauren Smith.

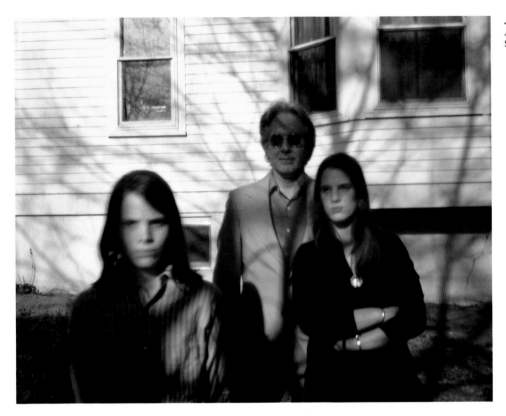

Jack, Adam, and Allya, St. Louis. Susan Hacker.

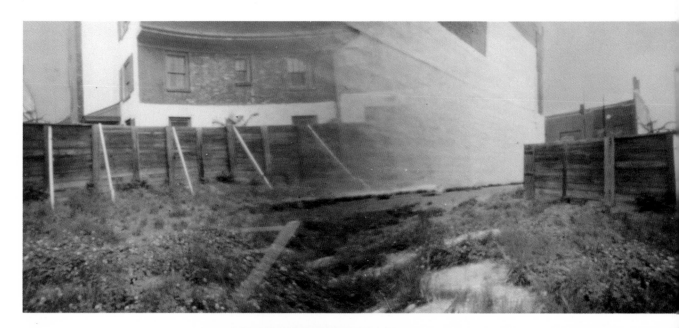

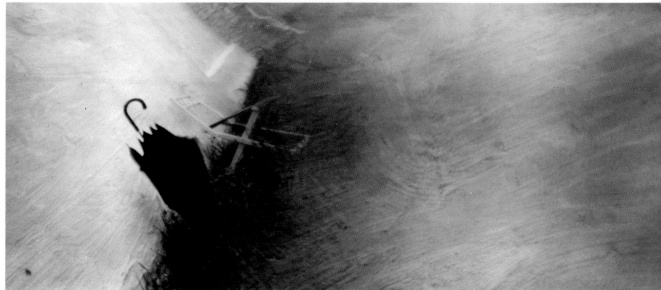

Susan, 1973. David Lebe.

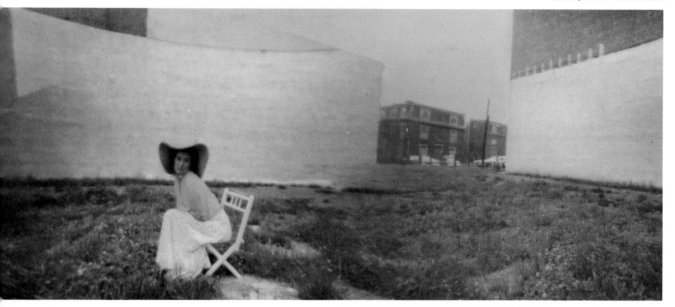

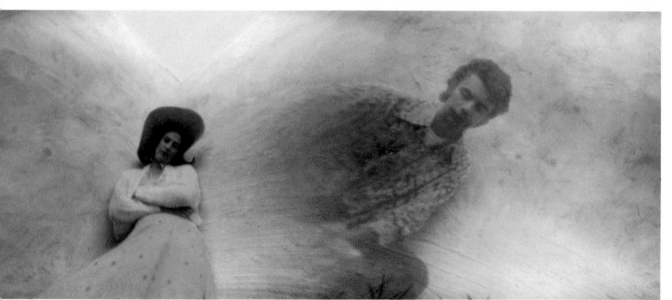

Susan and Me, June 1973. David Lebe.

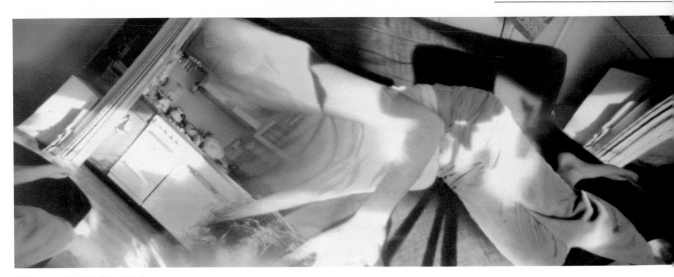

Self-portrait, 1973. David Lebe.

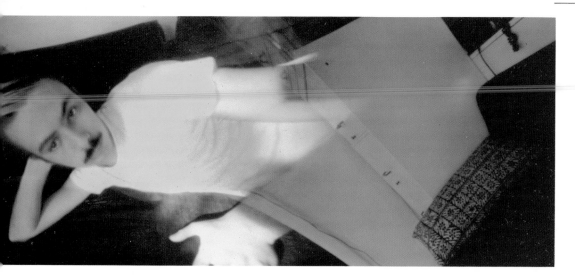

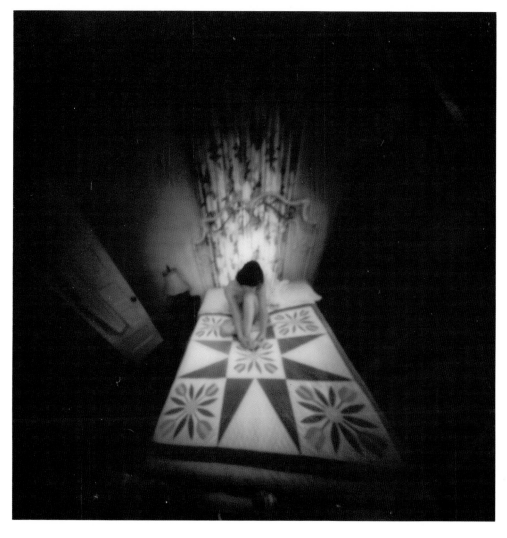

Joanne in Bed, 1977.
David R. Gremp.

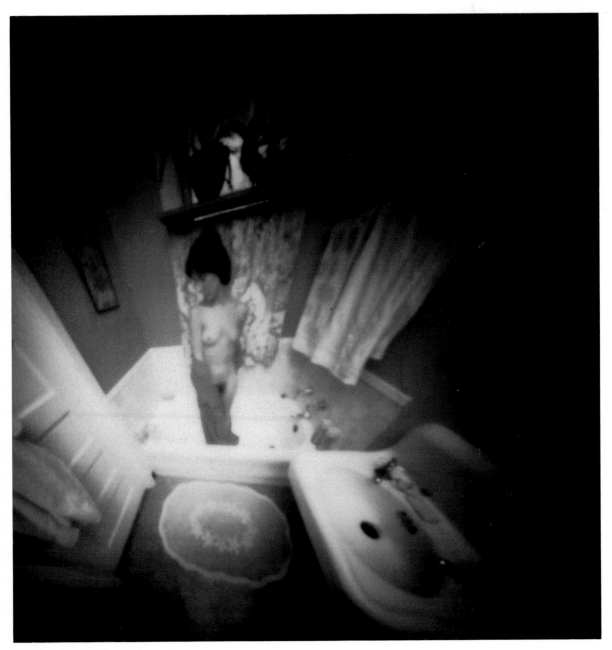

Joanne in Bath, 1977.
David R. Gremp.

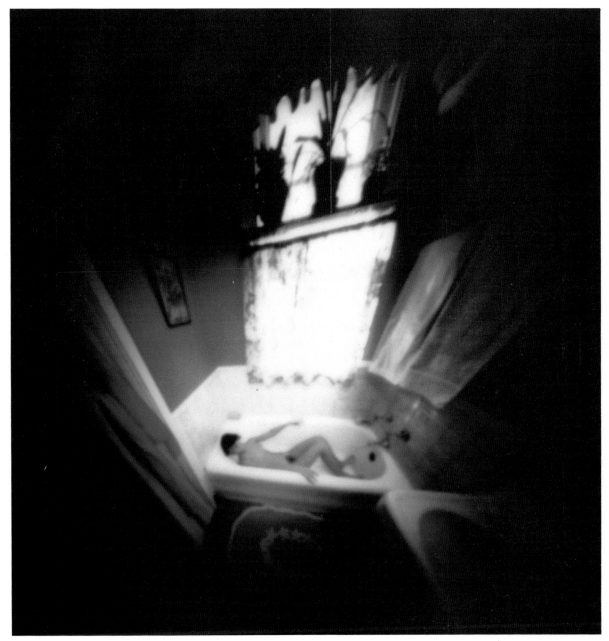

Joanne in Bath, 1977.
David R. Gremp.

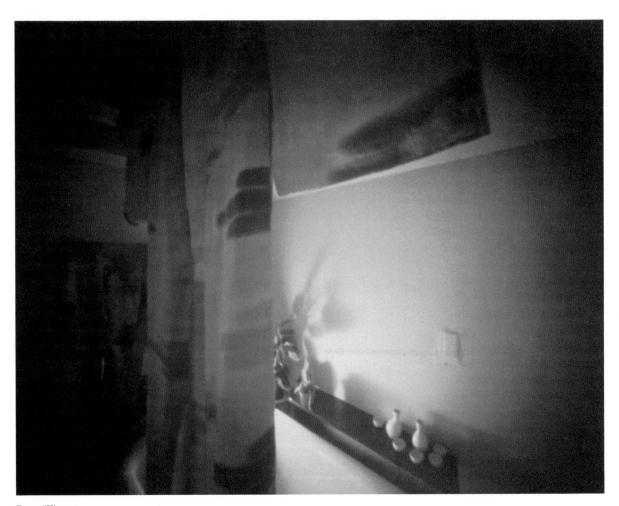

**From "Kimono
Heart/Mind Series."
Barbra Esher.**

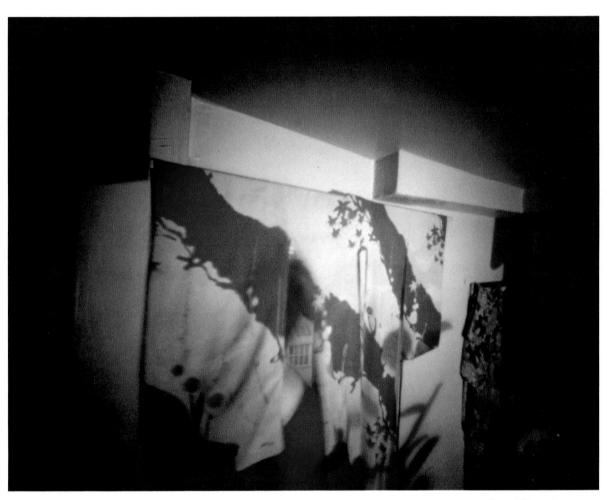

From "Kimono
Heart/Mind Series."
Barbra Esher.

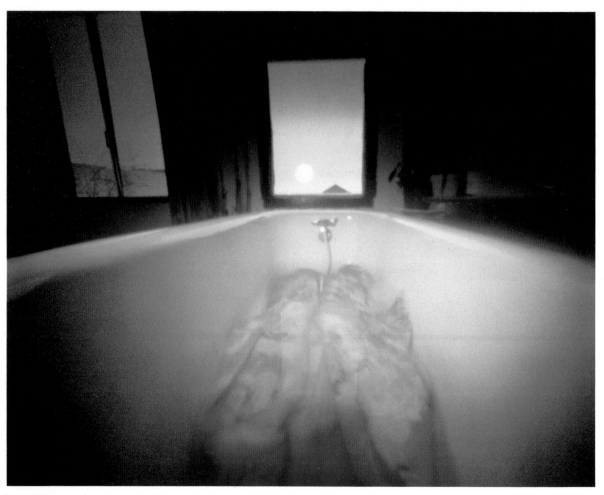

**From "Kimono
Heart/Mind Series."
Barbra Esher.**

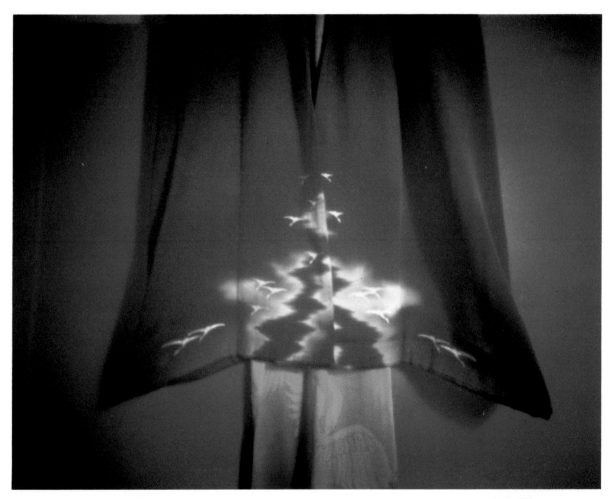

**From "Kimono
Heart/Mind Series."
Barbra Esher.**

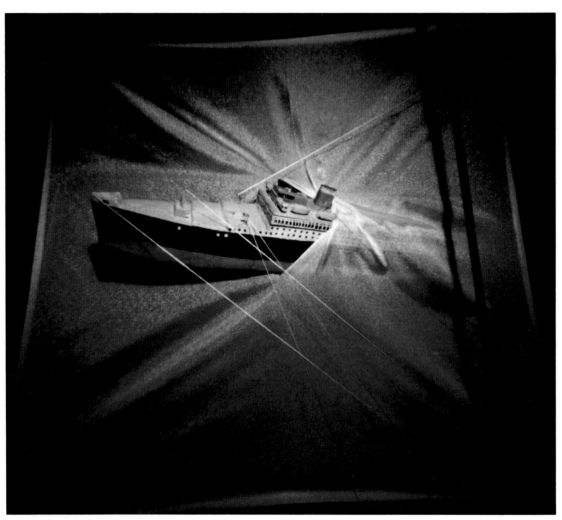

The Sinking.
Dale Quarterman.

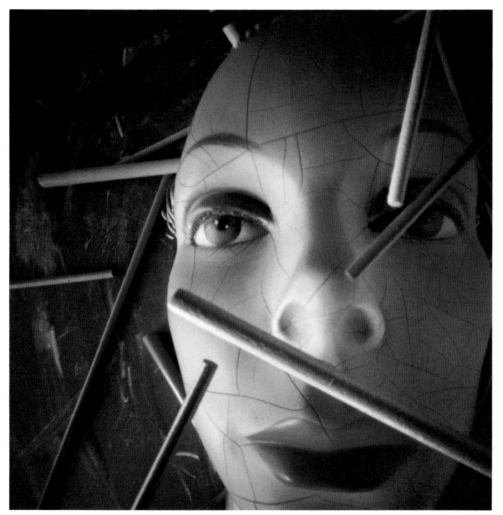

The Face.
Dale Quarterman.

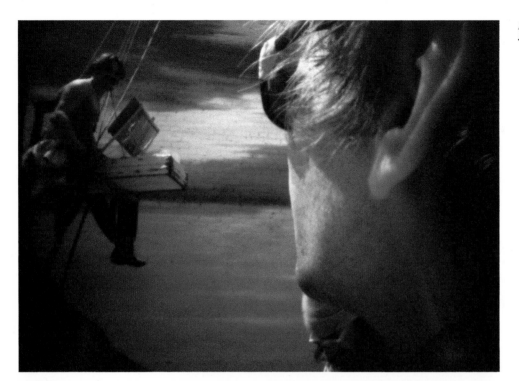

Dallas Mural Painter.
Jay Bender.

999. Jay Bender.

ARTISTS' STATEMENTS

PATTI AMBROGI

Patti Ambrogi teaches photography at Rochester Institute of Technology, Rochester, New York. Her work has appeared in *35mm Photography* and *Il Fotografo*. She states:

"A few summers ago, I made two hundred 16×20 negatives in my back yard garden. I photographed every day with my handmade cameras, finally closing in on a twenty-square-foot area. I returned day after day to the same spot, looking for relationships that would cause a shift in the pictures. Something existed in the garden that I could not see with my eyes and I exposed many of my negatives for hours, searching for that something.

"The pictures began to point out what I was looking for. They began to reveal that the garden and the process of photographing it shared a common power. It was as if the energy of growing things and the energy of making images had combined, had equalized, and had become each other within the picture plane. The photographs had undergone major changes and had pulled me along. Silently, deeply involved, I had complied. I remember only the discovering and the feeling of being completely absorbed."

ROBERT A. ARTHUR

Robert A. Arthur, of Boston, Massachusetts, is a registered architect. He is a recipient of a 1984 NEA Design Arts Fellowship. Arthur claims:

"My introduction to pinhole photography and camera design grew out of a desire to produce highly specific images without the use of an expensive and/or technologically sophisticated instrument. As I began to explore the medium, it became apparent that there are seemingly infinite options for shapes and sizes of cameras and hence, images. The cameras themselves provide an outlet for experimentation in design and craftsmanship.

"The cameras included herein have been designed and built for the primary purpose of photographing horizontal buildings in a panoramic format. Within this process I am most specifically interested in symmetrical buildings and a centered or balanced composition. The camera has a 120-degree angle of view and has been sized to accept half a sheet of 4×5-inch film, curved for even light distribution. Materials, all readily available and inexpensive, include chipboard, enamel paint, polyurethane, brass shimstock, photographic tape, automotive gasket sealant, and a T-nut for tripod attachment."

JAY BENDER

Jay Bender is a self-employed designer and manufacturer of large format "Bender View Camera Kits." His undergraduate thesis at Southern Illinois University discussed the optics of the pinhole, and Bender is now teaching photography at Illinois State University where he received his M.S. in art. Bender explains:

"I have been using pinholes, almost exclusively, for ten years now. Initially I became interested in the pinhole because of its wide angle and depth of field capabilities and its low cost. As I made pinhole photographs, I began to be drawn by many more qualities of the technique. There is a dramatic difference between the way a pinhole sees and the way a lens does. I think the pinhole is closer to human vision, partly as a result of the complete depth of field, but also because the images seem to have a warmth and intimacy lacking in those generated by the sterile eye of the perfectly machined lens. It seems to be a less frightening, more involving process for both the photographer and the subject.

"It makes sense to design and build a camera to suit a specific idea or situation rather than to use a camera designed by someone else for a multitude of purposes. I believe that art is more closely tied to experience than to objects, and it is important to me that the photographic experience be as personal and as rich as possible. Pinhole images are usually more like thoughts or recollections than records and, as a result, allude to human experiences more than to objects. Pinhole photography allows me a more personal, intimate involvement with life."

CLARISSA CARNELL

Clarissa Carnell received a B.F.A. from Tyler School of Art, Temple University, Elkins Park, Pennsylvania. She now teaches photography at the Fleisher Art Memorial in Philadelphia. Her work has been published in *Creative Camera, New American Photographs,* and *Afterimage.* She states:

"There is a song that gets stuck in my mind that goes, 'You think we're diving for gold; we know we're diving for pearls. . . .' No matter what you are up to, someone will always think you are up to something else. So, all I'll tell you is that I am having fun. What is the point of using a pinhole camera if it's not fun. Otherwise, it is too confusing."

CONCETTA DOMENICO

Concetta Domenico received her B.S. in art education at the University of Southern Maine in Gorham. She now teaches art in the Waterville Elementary School. She says:

"I live in Portland, Maine, and work as a photographer and art educator. I began to explore pinhole imagery in 1983 purely out of curiosity. I wondered how a small cardboard box with a brass plate for a lens could compete with today's sophisticated photographic technology. I became intrigued with the imagery that the pinhole produced. The uniqueness, spontaneity, directness, and above all, the magical quality of the pinhole, tempt me to explore it further."

BARBRA ESHER

Barbra Esher received her B.F.A. from the San Francisco Art Institute. She is now living and photographing in Tokyo, Japan. Esher states:

"The Japanese word *kokoro* means both heart and mind, not separated, but seen together as a whole. This series, in which I've chosen the kimono to explore the Japanese kokoro, was conceived and begun during a year's stay in Japan and nine months in America. When I first arrived in the countryside near Mt. Fuji, ideas of what I thought Japan would be like jumbled with my surroundings. I was staying with Japanese people who didn't speak English, and everything I did seemed to be wrong. As I frantically searched my dictionary for explanations, they patiently corrected me. Their kindness and consideration were amazing, embarrassing, and confusing. Learning Japanese was a step towards understanding what was going on but only because it changed the way I thought and felt.

"Permeating the language is an unselfish sensitivity to the other, whether another person or nature. Deference is expressed through a complicated system of honorific speech, which means you could address a person when you first meet him on one of about thirteen different levels. The choices of greeting are gradually narrowed according to age, social position, and the amount of familiarity developed.

"As a buffer to this other, directness is considered rude. Japan's is a culture of wrappers — postcards and books, or concealed jealousies and desires. Layer exists upon layer, only to reveal more wrappers. As well as privacy, this layering creates a curious mystery. Nothing is spelled out, but must instead be discovered. There's an unseen drama in the shadow which hides as well

as describes. It's important in Japanese to talk around the subject; something is lost in being direct. If the area around the subject is described and defined, then what you have left is the thing intact; not broken down, but as it actually exists—as a beautiful perfect whole."

TOBY LEE GREENBERG

Toby Lee Greenberg received her B.F.A. from the Tyler School of Art in Philadelphia, Pennsylvania. She also studied at Parsons School of Design in France, and at Temple Abroad in Rome. Greenberg states:

"I began the series of pinhole images included in this book during an extended visit to New York City. I must have desired to bring a little of my birthplace, New Jersey, the Garden State, to the steel-structured skyscrapers, for I decided to photograph nature as it merged with the man-made. I quickly realized that this was not such an easy task. I found myself in one of the rare places where this does occur however—the cemetery. Almost untouched by the life that looms outside its boundaries, the cemetery was a perfect marriage of nature and architecture.

"The pinhole camera was ideal equipment for the project. I preferred using a Quaker Oats oatmeal box as my camera because the wide angle and distorted view it created further enhanced the other worldliness of the place. While I could have used my sophisticated 4 × 5-inch view camera, I chose the pinhole camera for its simplicity and for the freedom it afforded me. The pinhole camera is so basic, so elemental, that it mirrors the spiritual fundamentalism of nature and the cemetery."

DAVID R. GREMP

David Gremp graduated with an M.A. in photography from Southern Illinois University in Carbondale. He is now director of publications at Calumet Photographic in Bensonville and is editor of the *Journal of American Photography,* a Calumet publication. Gremp states:

"While my involvement with pinhole imagery was short lived, it was, perhaps, one of the most exciting photographic experiences I have ever encountered. The images I produced combine the most basic and elemental equipment (a cardboard sheet-film box with a pinhole) with, at the time, the most technologically advanced material (Polaroid SX-70 film). It was simple. It was quick. It was fun. And it brought instant gratification in a beautifully wrapped package."

JIM HABERMAN

Jim Haberman is a photographer and sculptor living in the Boston area. His articles and photographs have appeared in numerous publications, including *Modern Photography, Popular Photography Quarterly,* and *Afterimage,* as well as in postcards distributed by Fotofolio. He is the past recipient of a photographer's fellowship from the Artist Foundation, Boston, Massachusetts.

"I became interested in pinhole cameras because they were so basic, and yet, I knew nothing about them. After making countless mistakes and building many crude cameras, I arrived at the wide-angle 4 × 5-inch pinhole camera I used for the portraits included in this book. I chose this design because the wide-angle perspective, the vignetted image, and the softened focus helped to convey the emotional tone I was after. I wanted to express a feeling of dreamlike solitude and a spirit of timelessness."

SUSAN HACKER

Susan Hacker received her M.F.A. in photography at the Rhode Island School of Design. She now teaches at Webster University in St. Louis, Missouri. Hacker states:

"Frankly, I first became involved with pinhole photography, not from the creative desire to experiment with an alternate type of image-forming apparatus, but simply because I acquired

a 4 × 5-inch view camera body without a lens. In order to make use of the camera, I mounted a pinhole made in brass shim stock on the lensboard and began to shoot. The bellows made possible my working at various focal lengths, from wide angle to telephoto. My exposures ranged from approximately 30 to 50 seconds. I usually photographed when it was windy or when the light was in flux in order to capitalize upon the long exposures. I find the beneath-the-surface quality of pinhole imagery to be mysterious and intense. The family portrait reproduced within this book is meant to convey the pinhole's inherent sense of enigma and energy."

PEGGY ANN JONES

Peggy Ann Jones of Corona del Mar, California, received her M.F.A. from the University of California, Irvine. Her background is in printmaking and sculpture. Jones states:

"To understand the unique qualities of pinhole photography one must examine the relationship between the camera and the image it produces. The pinhole camera is a tool, which, unlike a Hasselblad or Leica, is usually handmade. By creating one's own tool, the artist has the opportunity to experiment, discover, and interpret the potentials of the photographic medium. One finds that the specific physical characteristics of a camera's design are expressed in the photographs produced with that camera.

"My triple aperture photographs, included in this book, were produced with a camera whose three apertures are at varying focal lengths from a common focal plane. Resulting images combine with one another, sometimes in a layered fashion. What actually goes on inside the handmade black boxes remains a mystery to me. I merely try to make photographs which demonstrate some of that mystery. I try to make photographs that draw me back to them over and again, for, even though I create sculpturally interesting cameras, I am ultimately interested in the image, not the box."

DAVID LEBE

David Lebe studied at The Philadelphia College of Art and is now a part-time instructor of photography at that school. His work has been exhibited and published since 1973 and has appeared in *Darkroom Photography* and *Camera Arts,* among other places. Lebe says:

"Between 1969 and 1975, I worked extensively with pinhole photography, an experience which has continued to deeply affect my attitude towards my work. In 1974, I wrote about my pinhole photographs: 'Reality moves so fast that everything is either an expectation or a memory. . . . We experience many fragmented and concurrent images and perceptions which flow together instantly, creating a picture and a feeling of a scene. It is this flow of images and this sense of time that I want in my work.'

"Looking back now, I think that what was more significant than the concepts which motivated my interest in pinhole photography was the experience of doing the work itself. I began to walk out from behind the camera and into my pictures, becoming their subject and altering my earlier concept of photography. I became more of a participant and less of an observer. Having no viewfinder forced me to give up control and to stop previsualizing. I learned instead to set up situations and to work intuitively and spontaneously within their limitations. Since my pinhole cameras were not easily portable, I started constructing images in front of them.

"The experiences of becoming a participant, working with long exposure, learning to construct images, all led me to other photographic forms which include collage, painted photographs, photograms, "light drawings"—working with a flashlight in a darkened room over an extended period of time—and with still lifes and set-ups.

"The pictures included here are made with two cameras. One employs nine holes, the other four. In both cases the images are projected onto a curved surface that encompasses a view of

slightly more than 180 degrees. To expose the film, the holes can be opened simultaneously or individually, at random intervals and in any order."

MARTHA MADIGAN

Martha Madigan received her M.F.A. at the School of the Art Institute of Chicago. She currently is Associate Professor of photography at the Tyler School of Art at Temple University in Philadelphia. Her work has appeared in such places as *Afterimage, The New Art Examiner,* and *The Creative Camera.* Madigan says:

"My portraits were made with a cardboard pinhole camera in the spring of 1978. I asked pairs of my high school students to sit for a four- to five-minute exposure.

"I suggested that they talk about their friendship, their relationship with one another. A tape recorder was used to record the conversations while each exposure was made. The transcribed dialogue represents only a portion of the conversation in most cases.

"The pinhole camera was chosen so that information gatherings could extend over a period of minutes, rather than fractions of seconds. The cardboard camera also seems less threatening than a modern more typical, hand camera.

"Special, warmest thanks to the students of the North Shore Country Day School, Winnetka, Illinois. Without their energy and openness, this project would not have been possible."

BEA NETTLES

Bea Nettles, artist, author, and educator in Champaign, Illinois, has written *Breaking the Rules: A Photo Media Cookbook.* This book has sold over 12,000 copies and discusses various photographic processes. Another of her books, *Flamingo in the Dark: Images by Bea Nettles,* is a collection of the artist's own "kwik print" images. Nettles states:

"Those of my images included in this book are from a body of work entitled 'Close to Home' which was completed during the years 1980-1983. They were created from still lifes in my basement using a 16×20-inch pinhole camera. They are landscapes from my imagination utilizing household objects in arrangements that are based on events or my emotions. I am particularly interested and pleased with the spatial relationships made possible with a pinhole camera. Small objects become main characters, while large ones seem diminished. Quite often, the world presents itself to me in this fashion, and no other camera so well depicts this topsy-turvy phenomenon."

MARC PELOQUIN

Marc Peloquin received his M.A. at Framingham State College, Framingham, Maine. He is currently a medical photographer at Harvard Medical School in Boston and is the feature photographer for the *Yankee Magazine* and the *Harvard Magazine.* Peloquin tells about his work in these words:

"Basically, I am a New England regional photographer who photographs primarily in large format. In the summer of 1977, I took it upon myself to experiment with Haberman's design and technique in pinhole photography. I had met Jim as a student of Minor White and I was impressed with Jim's photographs. I tried photographing primarily organic shapes that would have a sense of drama as well as timelessness. My sources of inspiration for this pinhole work were photographs of Mars and the moon made from satellites.

"Those characteristics of a world removed from our everyday experience, which I was able to produce in this body of work, I now try to incorporate in more conventional large format (lensed) photography."

DALE QUARTERMAN

Dale Quarterman is an Associate Professor of photography at Virginia Commonwealth University in Richmond. He received his M.S. in photography from the Illinois Institute of Technology, Institute of Design. Quarterman states:

"My photographic images are made with conventional camera systems as well as the pinhole camera. At times, I feel the need to free myself from the technical trapping of modern photographic equipment. By using the pinhole camera, I am able to go back to the basics of photography in order to have total control of this magical and enjoyable act of painting with light.

"The pictures included in this book are 15×15-inch Ektacolor prints made from 4×5-inch Vericolor Type L negatives. The pinhole camera I use has a $1\frac{1}{4}$-inch focal length and accepts both 4×5-inch sheet film and a Polaroid back."

PETER REISS

Peter Reiss earned his M.F.A. in photography from the California Institute of the Arts. He now teaches at UCLA, Otis Parsons School of Art and Design, and at the Los Angeles Art Center of the Exceptional Children's Foundation. Reiss was also one of the ten artists commissioned by the Olympic committee to photograph the 1984 summer events. Reiss says:

"I am relatively new to the pinhole movement, but not to using cameras which have inherent characteristics that make them produce images that do other things than reproduce reality with the utmost clarity. I grew up under the tutelage of a newspaper photographer (my father) who was very interested in detail. In the early 1970s, I realized that I was much more interested in capturing the ambience rather than the detail of the world. As I continue to photograph, I realize more than ever that the mood in my photographs is the most important ingredient. Also, I accept it as a personal challenge to make elegant images with a large wooden box which is so crude that the sitter has to pose in front of it for up to five minutes."

ERIC RENNER

Eric Renner, of San Lorenzo, New Mexico, has worked with pinhole photography and has given pinhole workshops across the country for years. He has established the Pinhole Resource in San Lorenzo which acts as a research library and photographic archive, collecting information on the artistic and scientific uses of the pinhole. Renner says:

"My first pinhole photographs were 360-degree panoramas composed of six 60-degree images whose edges overlapped, creating an unusual proportional double exposure. After three month's work, I completed the large, hexagonal, hat-box type camera. One pinhole on each of the six sides of the outer box exposed the outdated 10×30-inch aerial film wrapped around the outside of an inner cylinder. Exposure times were approximately 45 seconds. Prints are contact prints. What a joy to work with negatives that large.

"Recently I was trying to photograph under water using a light-tight one-gallon pickle jar. I happened upon the optical principle of total internal reflection. All light rays that are attempting to leave the water past what is known as the critical angle (48 degrees, 35 minutes) are totally internally reflected back into the water. Each image displays bilateral symmetry. The bottom half of each image is underwater landscape; the top half is the underwater reflection. The two landscapes join at the pool's edge. If the water's surface is not perfectly still, the reflection is blurred."

For information about the Pinhole Resource write to Star Route 15, Box 1655, San Lorenzo, NM, 88057.

JULIE SCHACHTER

Julie Schachter received her M.F.A. at Mills College in Oakland, California. She now produces geotechnical graphics in the Bay Area. Schachter states:

"It seemed poetic justice for a Chicken Noodle Soup can to take a shot at Andy Warhol and produce the multiple pinhole portrait of its prime PR man. Thus began my enlistment of common objects into the service of photographic exposé. A detergent box, a T.V. set, a *Who's Who* book, a dusting powder box . . . each records images of life as seen from its particular viewpoint and of its natural surroundings. Pursuing such thematic connections allows me to indulge the urge to work with my hands by building the cameras as well as an individualized tripod for each. I hope the humor of my work encourages the viewer to cultivate his or her own unique, however quirky, way of seeing the world."

LAUREN SMITH

Lauren Smith graduated from the Ohio State University with a B.S. in English and an M.A. in photography. She states:

"My work is photographic. I produce freelance and personal imagery, curate photographic shows, write about photographic exhibits, teach pinhole workshops, and give lectures on photographic subjects. My life is my family and my work.

"The hand-colored images I chose to include in the book are selections from *A Primary Office Coloring Book* produced as part of an experiment concerning a physician's office. My intention was to discover whether the atmosphere of a medical office could be altered by using that space as a gallery for photographic art. The conclusion was that when people are in pain, they turn inward and do not percieve what exists around them. Therefore, an office, is an office, is an office.

"The Office images deal with the physical sense of the physician's space. Exposures were three hours. Film used was Ektapan. ASA was calculated to be 5 and aperture, f/128. Images were hand-colored with Marshall's oils and are contact Azo prints."

RUTH THORNE-THOMSEN

Ruth Thorne-Thomsen received her M.F.A. at the School of The Art Institute of Chicago. She is now Assistant Professor of fine art at the University of Colorado at Denver. Her work has appeared in such publications as *Vogue, American Photography Magazine,* and *The Print Collector's Newsletter.* She says:

"The pinhole camera is a playful and philosophical tool for discovery. Infinite depth of field is an inherent quality that enables the photographer to explore endless new relationships in scale. Because we cannot 'see' as the camera 'sees', we can only try to imagine. The results are always a surprise and a transformation.

"My work is an effort to combine elements found in the real world or even borrowed from other works of art to produce a separate and different reality."

THOMAS UPTON

Thomas Upton, of Palo Alto, California, is a freelance photographer who has done work for a variety of magazines, corporations, and advertising agencies. He received his B.F.A. from the Art Center College of Design in Pasadena, California, where he built his prototype pinhole camera. Upton asserts that:

"Pinhole photography is an outlet for me. The design of my 8 × 10-inch cylindrical camera came about while I was apprenticing in Los Angeles. I was contemplating my future and an extra-wide seamless container. The lens is made of shim brass drilled with a #80 jeweler's drill.

"The anarchy of pushing photographic principles to extremes appeals to me, because assisting had me creating flawless photographs every day. This is not slick commercial imagery meant to seduce your pleasure centers. The covering power of my lens begins to fail with the 8 × 10 film. The film is curved during exposure; previsualization is less predictable and hard to master. The element of surprise is reintroduced. And I have had fun with the philosophical implications that the camera is permanently focused on infinity."

GREG WILLIAMS

Greg Williams received his B.S. in photo-journalism at Bradley University in Peoria, Illinois. He is currently managing a photo lab. Williams states:

"When I realized that most of my photographic work was too controlled, I turned to the pinhole camera. I had been striving too hard for perfection in my photographs and the pinhole camera helped me to achieve spontaneity in my work. The camera I use at present was made from mounting board and a tin shim that has a pinhole in the center. The 4 × 5-inch negatives produced with the pinhole camera capture what I call Fantastic Realities. My most recent images are surrealistic impressions of simple urban landscapes, often shot from a ground-level perspective."

WILLIE ANNE WRIGHT

Willie Anne Wright is a native and current resident of Richmond, Virginia. Her pinhole work has appeared in *The Complete Book of Cibachrome, Darkroom Photography,* and *Poets on Photography.* She received her M.F.A. in painting from Virginia Commonwealth University. Wright is co-coordinator for the Virginia Society for the Photographic Arts and conducts pinhole workshops around the state. Wright states:

"Since 1972, I have been involved in pinhole photography and have exposed sheet film and photo paper in self-designed cameras. These negatives are then contact printed. In the past few years, my use of light-sensitive material has been extended to shooting directly onto Cibachrome for one-of-a-kind direct-positive color prints. At the present time, I use three pinhole cameras — 8 × 10-inch and 11 × 14-inch wooden boxes which accept film holders at each of three focal lengths, and a 16 × 20-inch box with one focal length that must be loaded in the darkroom for each shot. I have devised a filter system which corrects color balance for Cibachrome when used in either natural or artificial light. The camera usually rests on a tripod or other support for the long three- to six-minute exposures. The Ciba sheet is removed from the camera in the darkroom and is processed in a cylinder."